Contents

Acknowledgements

Thank you to all the artists who have made this third edition of *Ceramics and Print* possible through their artwork, sharing and generosity of spirit. It is telling that many have volunteered technical details, provided process shots and answered my questions without hesitation. This sharing and positive communication has been a consistent feature of the community of artists who have engaged with the synthesis of print and ceramics from its earliest days. To those whose work I have had to leave out, my apologies. In the first edition of the book finding enough images and illustrations was a challenge; this time editing pictures out has involved some very difficult decisions.

I am very grateful for the many institutions around the world that have hosted my Vitrified Print workshops over the past 20 years or so. These include universities, art colleges and academies, as well as artist-run workshops. Particular mention must be made of the Bergen National Academy of the Arts (KHiB, www.khib.no), the International Ceramic Research Centre, Guldagergård, Denmark (www.ceramic.dk), and the Kurszentrum Ballenberg, Switzerland (www. ballenbergkurse.ch) for their ongoing support over the years. Courses and masterclasses have acted like a research engine – those who have participated have not only enriched their artistic vocabularies but their explorations and ideas have formed an important part of the developing knowledge in the field.

Special thanks go to my wife Anne and daughter Ellen, who have tolerated my global wanderings and supported my diverse professional practice over the years with love and patience.

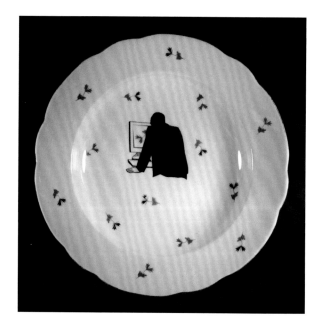

Felix Hug (Switzerland), *Untitled*, 2006. Overglaze screenprint decal on ready-made porcelain plate, diameter: 24 cm (9½ in.). *Photo: Felix Hug.*

Introduction

Ceramics and print have in common the ability to repeat a shape, form or image, and have been used together for hundreds of years to produce illustrative, decorative wares and tiles. Although ceramics are perceived as primarily three-dimensional, and print two-dimensional, ceramic surfaces are variously both. In the early 19th century printed tablewares formed part of the 'new media' of the age, democratising imagery, and disseminating pictures and landscapes that were once the preserve of the wealthy. With the new media of the 21st century, three-dimensional printing systems actually synthesise ceramics and print into one process.

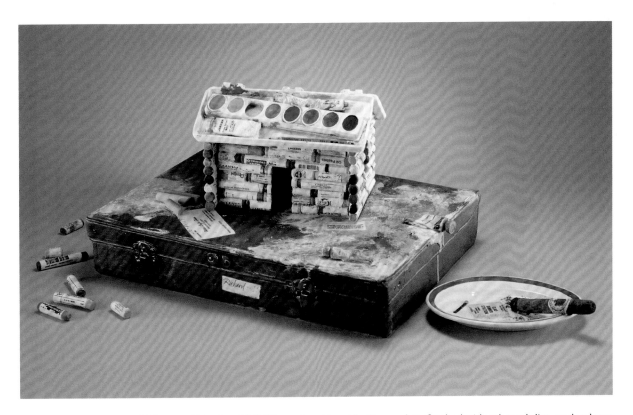

Richard Shaw (USA), *Pastel Cabin on a Paint Box*, 2007. Slip-cast and hand-built porcelain, finished with coloured slips, underglazes and glaze, with silkscreened overglaze decals, 21 x 46 x 28 cm (8¼ x 18 x 11 in.). *Photo: Charles Kennard.*

My first encounter with the graphic surface of ceramics was as a student at St Martin's College in Lancaster. As an escapee from the painting studio, I was encouraged in my ceramic explorations by the enthusiasm of tutor Barry Gregson, who promoted the diversity and potential of ceramics; 'you can do anything in clay' was a favourite quote. In one of his early lectures, he appeared wearing a deerstalker hat and carried a large briefcase. The sound the hat and briefcase made as they were placed on the lectern revealed that they were ceramic, as was his (porcelain) handkerchief and clay pipe. Gregson's subsequent lecture featured the tromp l'oeil ceramics of Richard Shaw and Marilyn Levine, and I was hooked.

I moved into the ceramics department almost immediately. I was more interested in the surface possibilities of the materials than issues of sculptural form. After a visit to Johnson's tile factory in Stoke-on-Trent, where I saw industrially produced screen-printed tiles, I came away with samples of reactive glazes and blank bisque tiles. In the studio, I painted an image in varnish onto a silkscreen, then printed through it with ceramic colours in an oil-based medium. The varnish blocked the mesh so that ink only appeared in the areas that had not been painted. Unintentionally, however, the process produced a subtly degraded series of images on tiles, as block-out varnish was progressively dissolved by the medium on each pulled print. I can still recall my enthusiasm as, after the squeegee was drawn across the screen, I lifted it to reveal the printed image on the tiles underneath. This sense of excitement when images are revealed is part of the fascination with printmaking in whatever form it takes. In the case of a ceramic print, it is further heightened by the additional process of firing that it is inevitably subject to. However experienced, every ceramist knows that whatever the type of kiln, and however predictable the materials and colours are, the glaze firing presents a period of excitement and anticipation. You are never *exactly* sure of what will present itself when you open the kiln door.

Many years later, whilst collaging with paper images onto fired ceramic surface, I became dissatisfied with the mixed media I was using. Much commercially-produced tableware was clearly printed, so I set about finding out how to replicate the process. I found that there were very limited print products available from pottery material specialists, and nothing ceramic at fine art print suppliers. When the few materials did arrive, there were no instructions on how to use them. There weren't even any labels denoting that the oils and lacquers could be dangerous to use. Documentary research in ceramics, then print handbooks, suggested that the two disciplines simply did not meet.

The subsequent time I spent experimenting and developing simple procedures were unwelcome distractions from the work I wanted to make, but I learnt a lot

John Stephenson (USA), *Floor Vase,* 1965. Stoneware hand-built form with impressed print from newspaper plate. *Photo: courtesy of John Stephenson.*

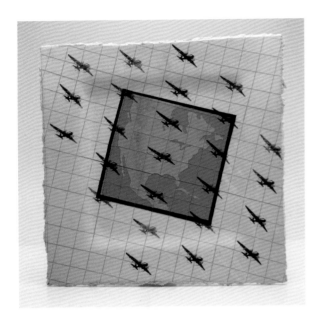

Greg Payce (Canada),
Plate 1984, 1984. Ceramic
monoprint with slips (plaster
transfer), screenprinted
overglaze decals, 40 x 40
x 6 cm (15¾ x 15¾ x 2 in.).
Photo: Greg Payce.

about materials, transfers and techniques. Some of the research was enjoyable but other procedures were simply necessary evils to go through to get a finished result. I resolved that no one should have to start from such a base level again. So the idea of the *Ceramics and Print* handbook was born.

Over 20 years ago, when I first researched the field, it was quite difficult to find artists using print with clay. Part of the reason was that, in Britain, contemporary practice was defined by the studio pottery movement. As an early 20th-century invention, this was born out of the Arts and Crafts movement and was fundamentally opposed to industrial process. Printing was never part of its lexicon. If you examine issues of specialist publications *Ceramic Review* and *Ceramics Monthly* from 35 years ago you will get the impression that printed surfaces were virtually non-existent in contemporary practice.

In fact, I later learned that there was a good deal of experimentation and resolved artwork involving print and clay being made, it was just not being written about. As early as 1965 John Stephenson was pressing by-products of newspaper production, discarded type sheets, into soft clay and creating forms with the resulting relief printed surfaces, but there were many other pioneering artists who ignored the strict boundaries of traditional material disciplines to synthesise practice in new work.

Such a dramatic transformation in perceptions and attitudes has taken place since the publication of the first edition of this book that by 1999, *Ceramics in Society* magazine was moved to observe that printing had become recognised as 'an integral part of current studio practice'.[1] Browse the pages of any ceramics magazine today and you will see plenty of examples of graphically-developed surfaces and objects; it is because of this proliferation of practice that the original edition of *Ceramics and Print* has now become dated. From decorative icons on slip-cast ceramics, experimental one-off prints, limited edition decals on plates, large-scale commissioned work for public places, to conceptual pieces relying on the printed image and the object's connotations of function, the field is wide and has grown considerably. At a time when some perceive material disciplines to be in retreat, ceramics and print has been an area of growth, experimentation and innovation.

In revising the book, it has been my intention to bring it into the 21st century. One of the reasons has been my experiences of the Vitrified Print workshops I have been fortunate enough to run in places around the world over the past 20 years. I am grateful to all the institutions that have hosted these, as well as the enthusiastic students who have run with my non-formulaic presentations and teachings. They continue to discover new processes, techniques and refinements to ways of working

1 *Ceramics in Society Magazine*, No. 37, Autumn, 1999, p. 6.

which have greatly enriched and extended the field of knowledge. They have been a part of a research engine driving material and technical innovations. The new book has also been made possible by the generosity and sharing of information that is typical of those working in the field.

Some complained that earlier editions of *Ceramics and Print* gave a tantalising glimpse of what was possible, but didn't give the exact route to follow to get the results, or give the specificity that other texts offer. This was (and is) quite deliberate. If you want a book that takes you by the hand and instructs you step by step through a series of prescribed processes, using specific materials (types of clay, brands of products), this is probably not the one you are looking for. If, however, you want to understand the synthesis of ceramics and print so that you have the confidence to experiment with materials and develop your own personalised

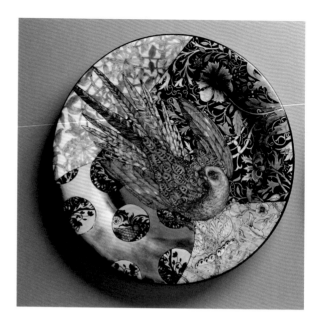

effective processes, this *is* for you. My purpose is always to describe the basic and illustrate the possible, with the intent of engendering exploration and innovation. You will need an enquiring mind; be prepared to take some risks and accept a few failures on your journey. If you do, you will find unexpected ways to print that are simple, or more complex, than you thought possible. This book will lead you through all the basic concepts, and several pretty complex ones too, that are required to understand and make printed ceramics.

Most of the techniques outlined in the original book are here, as well as many completely new developments and adaptations. The text has been re-written to help build knowledge from basic transfer concepts to develop material understanding. It also reflects the nature and emphasis of contemporary practice more accurately than ever before. Images in the text have been selected to highlight thought-provoking work alongside the illustrative. For this edition, choosing images has been one of the hardest tasks; I have had to edit out many excellent artworks due to lack of space.

As before, references in the bibliography (p. 141) will guide the reader to more detailed books and websites on printmaking and ceramic processes. Health and safety issues are addressed in a separate section and web listings include contemporary specialist suppliers.

Ceramics and print lack a traditional grounding in the academies of fine arts and until recently have been seldom taught in applied arts courses or programmes. As a result, there are few rigid rules or procedures. A little knowledge, an enquiring mind and a willingness to explore will produce graphic ceramic results. With this small handbook, and a little intelligent searching on the web, you will have far more to go on than I did when I first started my investigations.

Paul Scott, March 2012

Stephen Bowers (Australia), *William Morris camouflage plates*, 2012. Earthenware, underglaze colour painted, and decal, clear earthenware glaze, onglaze gold lustre, enamel, 32 x 2.5 cm (12½ x 1 in.). *Photo: Grant Hancock.*

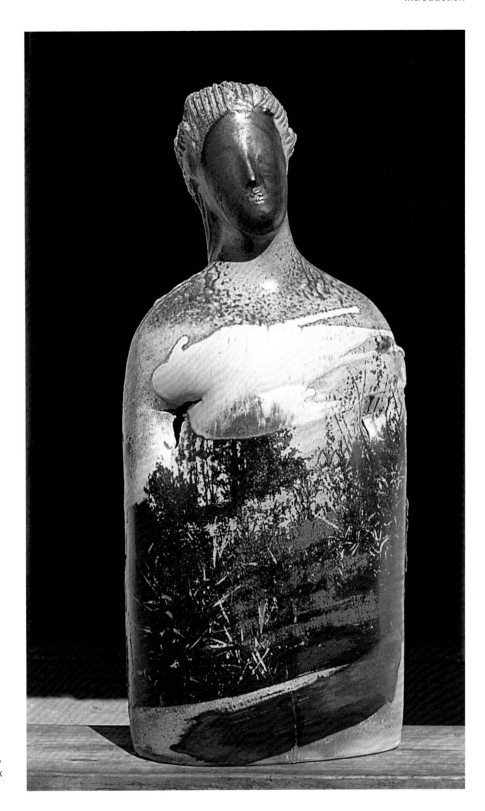

Maria Geszler (Hungary), *Rousseau's Garden*, 1991. Self-portrait, porcelain silkscreen, wood-fired and salt-glazed ,1320°C (2408°F), 78 x 32 x 14 cm (30¾ x 12½ x 5½ in.). *Photo: Maria Geszler.*

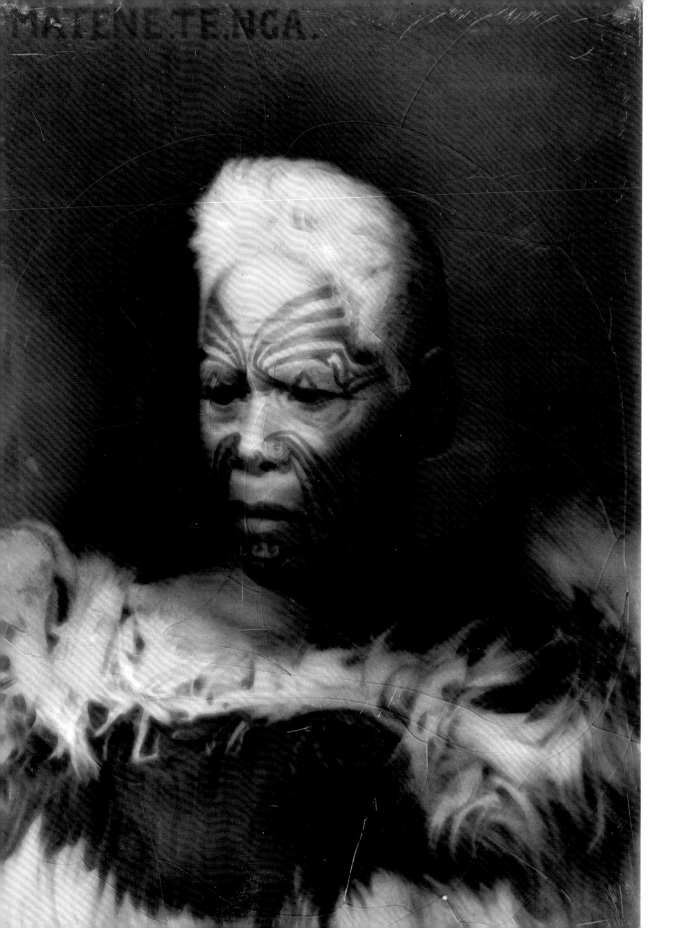
MATENE TE NGA

Historical and industrial background

A knowledge of the contexts of past production processes helps in the understanding of current practice as well as in the development of new methods and techniques. It can also be key to the realisation of meaningful artwork. The purpose of this chapter is to outline a short historical background.

Plastic clay has many properties, not least among them the ability to faithfully record impressions in its surface, from the fossilised ghost of a fish skeleton or the earliest potter's thumbprint, to simple patterned designs stamped into its surface. It could be argued that potters were the world's first printers.

The first use of print in the context of transferring a ceramic colour from one body to another (other than painting) seems to have been the use of natural sponges to decorate pottery. Splatterware was a type of Minoan and Mycenaean ceramics, in which sponging was used in a relatively random way to produce a mottled effect in contrasting slip on a clay body, possibly imitating the markings on ostrich eggs. The patterning was most commonly used on bottle and cup forms. The process reappeared in Europe in the middle of the 19th century, with mottled greens and browns under a transparent lead glaze.

RELIEF PRINTING AND INTAGLIO: THE INVENTION OF THE TRANSFER

For centuries the only other printing on clay appears to have been the use of stamps made from wood, clay or some other material to decorate by impressing into the clay surface. Stamps facilitated the simple repetition of shapes creating patterns and designs.

The combination of impressing and transferring colour does not appear to have been made for centuries but medieval tiles seem to show this as the next development in print. Between the 13th and 16th centuries, tiles with contrasting colours provided rich patterned floors in royal palaces, and ecclesiastical and monastic buildings. They were essentially terracotta tiles with painted or inlaid white/buff clay designs depicting stylised foliage, and geometric and heraldic images. It is clear from the style and quantity that many tiles were made using wooden stamps or moulds. A contrasting clay, in plastic or slip form, was applied into the indented areas of the stamped or moulded tile. When the tile was dry, the surface was carefully scraped back and the stamped design appeared, usually white against a red clay background.

Earthenware tile with portrait of Matene Te Nga, designed by George Cartlidge for Sherwin & Cotton, Hanley, Stoke-on-Trent, c. 1911–24. One of four tiles depicting Maori chiefs and guides from Rotorua, New Zealand, who visited London in 1911 as part of a cultural group promoting the country. Matene Te Nga is listed as 'Maori Chief' in Tony Johnson's book, *The Morris Ware, Tiles & Art of George Cartlidge*. *Photo: courtesy of The Potteries Museum & Art Gallery, Stoke-on-Trent.*

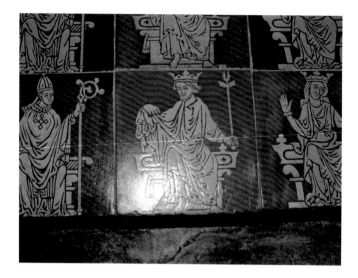

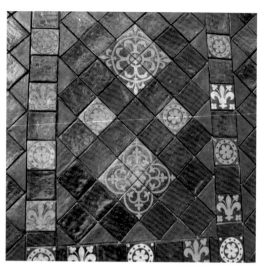

Renovated medieval tiles in Tidmarsh Church, repairs by Diana Hall. *Photo: courtesy of Diana Hall.*

Replica medieval tiles by Diana Hall. *Photo: courtesy of Diana Hall.*

In the meantime, printing on paper continued to develop gradually. Initially primitive woodcuts on paper were simply rubbings from carved wooden blocks, but by the middle of the 15th century, prints from metal engraved plates were being made in roller presses, and the printing press had been invented.[1] Printing from engravings involved transferring colour from lines cut into metal plates and allowed much finer detail than the surface prints of wood blocks. By the beginning of the 17th century, engraving and etching, which involved using acid to chemically cut into metal plates, were common.

Although Dürer, Rembrandt and other visual artists began to explore the creative and economic possibilities of etching, both processes were essentially reproductive mediums, disseminating fine art and illustrative imagery to an increasingly wider populace. As a media form, matters of taste, expression and creative possibilities were secondary to a system of reproduction in which economies and efficiencies were paramount. In the true spirit of industrialisation, the skills of making plates were divided. Original artwork was adapted by a draughtsman for a specialist, who made a preliminary etching on metal before the engraver finally worked up the plate, probably without ever having seen the original image.

As engraving and etching became widespread, a range of printing inks and oils became widely available. Pigments used on paper included carbon lamp black and other materials that would not survive a firing in a kiln. At the same time an increased range of ceramic colours, developed from metal oxide mixtures for use on tiles, plates

1 Irvins, W M 1969, *Prints and Visual Communications*, MIT Press, Cambridge, MA.

and tableware, were being developed. Cobalt blue, first seen on Chinese porcelain, became highly desirable during the 17th century. It was used on imitative Delftware, later supplemented by purple, yellow, green and orange pigments.

The technology of paper print eventually combined with the ceramic, although the exact date of the invention of ceramic transfers is open to debate. The most quoted is John Sadler of Liverpool, who in 1749 is said to have observed children sticking bits of paper to broken pottery. Six years later he swore an affidavit in which claimed that he and a colleague had perfected a printing system. Robert Copeland, on the other hand, cites evidence that transfers were used in the Doccia factory as early as 1737.[2] By the end of the 18th century, printing from copper plates was common in the pottery industry.

At first transfers were effected by a system of 'bat printing'. Images and patterns were engraved on copper plates using cut lines and punched dots. Printing plates were then inked up using a soft rag or cloth soaked in oil (one recipe instructs the use of '1 pint of linseed oil with a spoonful of pulverised umber boiled for 30 to 40 minutes', the surface wiped clean, 'with the hand as in common copperplate printing'). The image on the plate in oil was transferred to the fired ceramic surface with the aid of a glue 'bat' approximately 7 mm (¼ in.) thick. When pressed onto the copper plate, the bat picked up the oil embedded in the cut lines and dots. It was then placed face up on a 'boss' (a soft leather bag filled with bran or wool) before being pressed again, this time onto the fired ceramic surface. The latent image or pattern in oil, transferred from gelatine or glue bat to pottery surface, was then dusted with ceramic colour. Pigment stuck to the oiled area so that the image or pattern originally engraved in the copper plate appeared. The amount of ceramic colour held by the oil after dusting was limited so the process was only suitable for onglaze or enamel colours. Underglazes, which are part dissolved in glaze, demand a heavier deposition of ceramic pigment.

At around this time machinery was being developed that made possible the production of large quantities of smooth, fine papers, and strong tissue replaced the glue or gelatine bat as the main transfer medium for pottery printing. Harry Baker from Hanley made a patent in 1781 for four printing processes. What he described is a basic process for transfer printing:

> Take a sheet of thin paper and having dissolved some gum arabic in water, spread it with a pencil on one side of the paper; let it dry; then take one part of balsam of amber and one part of Venice Turpentine for ink; put the copper plate on a charcoal fire or stove to warm and into this ink put such a colour as you please to print with, and rub it into the plate ... put the plate with the gummed paper through a rolling press, take it off the plate and put it onto the glass; rub it with a flannel to fix it to the glass, then soak in water and the whole impression will quit the paper and be left on the glass.[3]

2 Copeland, R 1990, *Spode's Willow Pattern and Other Designs After the Chinese*, Studio Vista.
3 Ibid.

Tissue-printed *Willow Pattern* plate, c. 1850, from the author's collection. As technology for printing became more widespread, printed tablewares became more widely available. This plate, made of a poor quality earthenware, has been hurriedly produced, the general smearing of blue evidence that the copper plate was not properly wiped clean. It is also clear where the tissue print has been cut and applied, diameter: 23 cm (9 in.). *Photo: Paul Scott.*

When the first underglaze printed patterns appeared around 1785, exotic Chinese designs on painted porcelain, with their flat, layered compositions, were the first to be effectively replicated by early engraved prints. The bold, flat, painted patterns of the oriental landscape were perfect for reproduction, and copper plates were engraved with heavy, deeply-cut lines. New mass-produced patterns began to appear alongside the oriental. The shift in production was not a clean break with the decorative symbolism of the past. Industrial designers borrowed indiscriminately – Chinoiserie hybridised with the European in confected illustrative symbolism and decorative border.

Thousands of printed designs graced the surface of blue and white pottery during the 19th century. Whilst engravings were made to order for plates, cups, jugs and tiles, many were pseudo-Chinese in origin; others were taken from engravings based on classical paintings or illustrations in travel books. Some were specifically made for overseas markets. Robert Copeland recounts how North America was used as a dumping ground for pottery that was not up to standard or had gone out of fashion. This 'substandard' ware is described as 'flow blue'. Haines Halsey in 1899 recounts a report of its origins:

While visiting the Potteries at Trenton nearly 20 years ago, Mr. William C. Prime found an aged Englishman, who, being asked about the dark blue pottery of Staffordshire, related from his own experience the following story which Mr. Prime accepted as the origin of the dark blue decoration. One day some potter, on taking their wares from the oven, found that the blue coloring had overflowed on the surface, nearly obliterating the design. The foreman considered the day's work a failure, but the owner who chanced to be passing, thought differently, and said: 'Oh, they will do for the American market.' Much to his surprise, the consignment sold instantly upon arrival, and a large order sent for a similar lot non-plussed the potter; for his success was the result of a mishap.[4]

A complex range of different patterns was developed, and an elaborate visual vocabulary of images and patterns built up.

In the 1950s a more sophisticated adaptation of bat- and copperplate printing transfer, the 'Murray Curvex' system, allowed for rapid mass production. A machine forces a solid convex pad of gelatine or silicon onto an inked copperplate engraving; picking up the pattern or image, it then transfers the colour directly to the ceramic surface of the ware to be decorated. In this process, the copper plates are deeply engraved, and the inks used are in media made from synthetic oils. The process is usable only on 'flatware', but adaptable for onglaze and underglaze decoration. The basic process of prints from engraved coppers is sparingly used some 200 years later at Portmeirion (who still produce a select few of Spode's iconic patterns) and Burleigh Potteries in Stoke-on-Trent.

Multicoloured prints from up to five separate copperplate engravings were made for a short time from the middle of the 19th century. Each separate colour was applied to the ware in the normal manner, allowing two days drying between each colour transfer. To enable accurate registration, small dots were incorporated into the designs. The results were beautiful elaborate images much used in their heyday on pot lids and containers for toiletries, meat pastes and other delicacies. The process was labour-intensive and required above average skills. In the economics of a competitive industry, multi-plate engravings had a limited life.

The use of other colours for printing onto pottery is linked to the different processes of printing – relief printing, lithography and screenprinting. Wooden blocks, long used in fabric printing, and prints from the end grain of box wood, commonly used in books at that time, had some life. In this process, instead of the incised area being inked up, the uncut surface was inked, and large areas of colour were printable. They were used on the same transfer paper process as engraving. The common problem in inking wood with ceramic colour was the amount of ink required to get a good line or even area of colour. Wood-block prints are detectable by the choking of fine lines with colour, or a darker line at the edge of block-printed areas. Metal block plates (using zinc) were less problematic and have been used into the 20th century.

4 Haines Halsey R. T. 1974, *Pictures of Early New York on Dark Blue Staffordshire Pottery*, Dover Publications, New York (reprint of a book published by Dodd Mead and Co., New York, in 1899), p. 16.

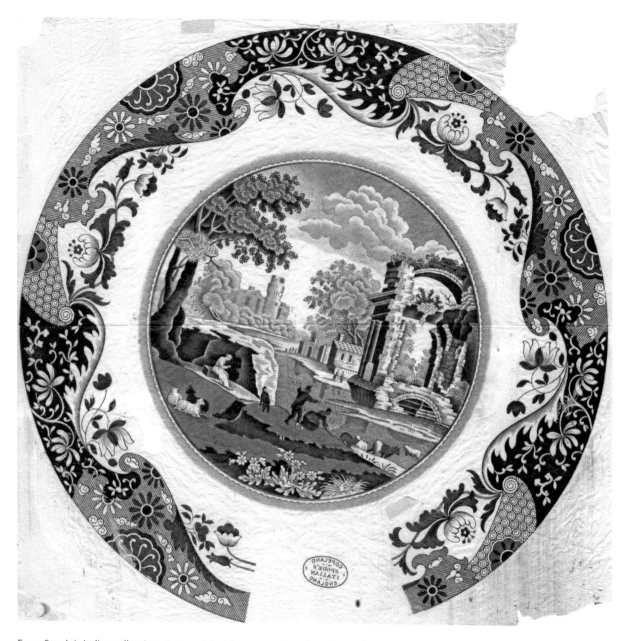

From Spode's *Italian* collection, tissue-printed from engraving, from the author's collection. *Photo: Paul Scott.*

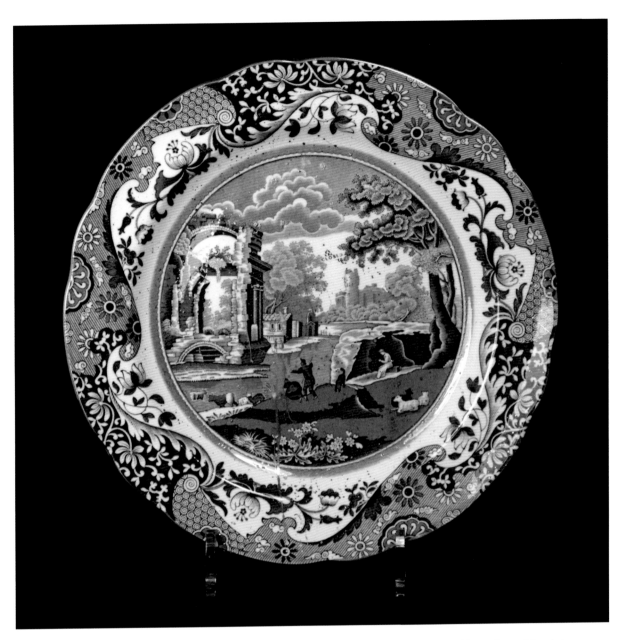

Paul Scott (UK), *Scott's Cumbrian Blue(s), Spode Works Closed (06/11/09)*, 2009. Inglaze decal and gold on salvaged Spode bone china, collected from closed factory, diameter: 25 cm (10 in.). *Photo: Paul Scott.*

Choir of the Chapel, Royal Savoy Destroyed by Fire, July 1864. Pot lid with polychrome print, c. 1865. An example of the role of illustrative ceramics in commemorating events, including the tragic. Author's collection, diameter: 10 cm (4 in.). *Photo: Paul Scott.*

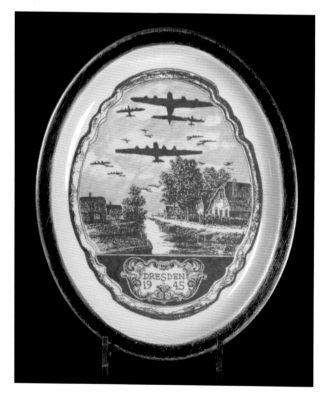

Charles Krafft (USA), *Disasterware© 30/50,* 1995. Overglaze decal print on old restaurant-ware, marked 'Buffalo China USA'. At the end of the 20th century, Krafft's Disasterwares updated the historical genre with a series of plates depicting assorted tragedies. The Dresden plate actually depicts a bomber flying over a Northern Dutch landscape, the landscape image based on a 19th-century painted Makkum plaque depicting a canal in Zuid-Holland,[5] 30 x 24 cm (11¾ x 9½ in.). *Photo: Paul Scott.*

5 See Tichelaar, Pieter Jan, and Polder, Casper 1998, *Fired Paintings 1870–1930*, Primavera Press, Leyden.

SPONGE AND RUBBER STAMP DECORATION

The most successful 'block' or relief prints on a commercial basis were used on spongeware. The making of spongeware was a distinctively (but not exclusively) Scottish industry having its heyday in the latter half of the 19th and the early part of the 20th centuries. Early sponge decoration involved the use of a natural sponge in a loose and fluffy state, dipped in a medium containing ceramic colour, and pushed in contact with the biscuited surface of the pottery. The decoration was relatively random and abstract. It was sometimes heavily loaded with cobalt to create 'flow blue' ware, in which the colour bled to such an extent that the white body appeared pale blue, with the printed area appearing as flowing, darker-blue patterns or shapes.

To print more regular decoration the sponge was tied with linen threads. This had the effect of pulling the sponge into a denser mass, the threaded areas determining the shape of the pattern. To many people, though, spongeware is pottery decorated with the cut, smooth root of the natural sponge. The root of the natural sponge is dense but still flexible and absorbent, and its use enabled potters to make quite detailed stamps. These were used to decorate earthenware pottery with bright patterns and designs, which was exported to the British Colonies, West Africa, and North and South America. On some lines, sponge decoration was used in conjunction with copper-engraved transfers but in general, compared to engraved transfer prints, the decoration was crude, and the clay bodies used tended to be coarse. References to spongeware in books on pottery decoration are few and far between, and where they are made they are generally rather dismissive, the phenomenon being seen as cheap and vulgar. It was perhaps viewed this way in its own day, for comparatively little (compared to transfer-decorated and other contemporary pottery) seems to have survived. The Scottish spongeware industry folded in the late 1920s as a result of the Great Depression, although some ware was produced into the 1950s. In the contemporary pottery industry, spongeware, with its naivety, immediacy and 'handmade' quality, is making something of a comeback.

On tableware decorated with copper engravings the bottom stamp was included in the tissue print. It was simply cut out with the rest of the designs, and applied in the normal manner to the base of the object. Sponges were too crude to allow for bottom stamping, and so at some stage before 1890, the rubber stamp was introduced. Unlike sponge decoration, which relies on the absorbency of the printing material, the rubber stamp transfers colour to ceramic surfaces by picking up colour mixed in a sticky medium. Rubber stamping further developed in the 20th century, when it was used to decorate gold lustred borders on bone china and porcelain.

Three processes have revolutionised printing since the invention of engraving: lithography, photography, and screenprinting (or serigraphy – drawing on silk).

Brixton Pottery (UK),
Geranium side plate, 2012.
Diameter: 18 cm (7 in.).
*Photo: courtesy of Brixton
Pottery.*

Lithographic stones, printed
sheets and tableware
at the Bernardaud
Museum, Limoges, France.
*Photo: courtesy of the
Bernardaud Foundation.*

LITHOGRAPHY

Munich playwright and composer Alois Senefelder discovered the process of lithography in 1797. Lithography (from the Greek *lithos* – stone, and *graphio* – draw) relies on the natural repulsion between grease and water. In its most basic form, an image is drawn on a specially-prepared slab of fine limestone with a greasy crayon. The slab is then flooded with water and inked up with an oil-based ink. The ink is repelled by the water, but sticks to the greasy areas. Paper is laid onto the litho block, and under pressure the inked drawn marks are transferred. By repeating the process in a press, numerous identical images can be printed. At first, lithography was exploited by the paper printer, and was adapted for use on pottery in continental Europe. It was some time before the British pottery industry took it up with any enthusiasm, but Susie Cooper developed them to a fine art in the 1930s. She worked on separate plates for different colours, in a similar manner to the multicoloured copperplate prints being used on pot lids almost a century earlier.

The process of making the litho plates was much less labour intensive than engraving and the quality of the image quite different – much closer in appearance to original paintings or drawings. Specialist adaptations of tissue paper were produced to make the process workable. Duplex paper (used until relatively recently) consisted of a thin sheet of tissue with a much thicker paper backing. The thick paper backing allowed for stability in printing colours in register, and this was removed before the image was transferred to the ware. The tissue paper possessed the flexibility for transfer of the image to curved ceramic shapes. Ceramic surfaces were painted with a weak varnish that, when tacky, held the lithographically-produced print. As with the copperplate transfers, the backing tissue paper was soaked and rubbed off before firing.

Like the bat printing process, ink thickness is relatively fine, so lithography was primarily used for onglaze or enamel colours, but sometimes also for inglaze cobalt blue.

In industry, zinc and polyester plates have replaced limestone. The porous nature of the stone is simulated by graining a slightly textured surface made up of tiny recessions capable of retaining moisture or grease.

SCREENPRINTING

Screenprinting, probably the most common process associated with graphic ceramics, developed from katazome stencilling, which first appeared in Japan in the early 18th century. Isolated parts of stencils had to be attached to the main body of the stencil, so bridging sections were very obvious once designs became more elaborate. One solution was to cut two stencils of exactly the same shape and size. Human hairs were glued across the shapes of the first, holding isolated elements in position. The second stencil was glued on top, sandwiching the fine threads. Painting or dabbing colour through the mask resulted in a 'print' without bridging struts. Hair support was eventually replaced by a more sophisticated resolution – silk mesh.

The first industrial application of screenprinting in the early 20th century involved a cut-stencil process, printed onto fabrics. In New York in 1939, Anthony Velouis developed a process that dispensed with the laboriously-created cut stencil. The blank screen was drawn onto with a waxy or lithographic crayon then washed with a glue solution. When set, a solvent was poured over the front and back, which dissolved the wax, creating open areas of screen where the image had originally been drawn. Subsequently, photographically-sensitive emulsions have made screenprinting an even more versatile medium.

The first silkscreen-printed tiles in England were attributed to Carter's of Poole in the early 1950s. Now it is the primary process for ceramic printing because it is so versatile. It enables direct printing on cylindrical as well as flat forms. It can be used to print wax resist, glaze, onglaze, underglaze and heated thermoplastic colours (so that the printed piece does not need another firing).

The development of decals revolutionised industrial decoration. Images or patterns in ceramic colour are printed in an oil-based ink onto gummed absorbent paper, over which a liquid thermoplastic layer, covercoat, is applied in liquid form. This sets on drying, enveloping the print. When placed in warm water, the covercoated print is released from the absorbent paper backing. The print can then be slid off, gum residues sticking it onto the glazed ceramic. On firing, the plastic burns out cleanly, leaving the printed image in or on the vitreous surface.

A simpler system, often associated with contemporary printed blue and white ware from Asia, involves printing underglaze ceramic colour with water-based media onto thin tissue or rice paper. The print is applied to greenware or bisque by wetting the ceramic surface and laying the print in place, before also dampening the back of the paper with a brush or sponge whilst applying pressure.

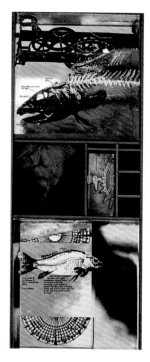

Paul Mason (UK), *Natural/ Mechanical Box*, 1995. Made for the *Hot off the Press* exhibition in 1995, which was curated as a result of the success of the first edition of *Ceramics and Print*. Silkscreen-printed ceramic tiles with lustre, distressed with silicon carbide paper, 48 x 16 cm (19 x 6¼ in.). *Photo: courtesy of Paul Mason.*

Screenprinted tile made by Carter's of Poole, onglaze colours, c. 1952. *Photo: Paul Scott.*

PHOTOGRAPHY

Photography's greatest impact in printing and ceramics lies in the use of photosensitive emulsions in intaglio, lithography and screenprinting. However, before these were developed, directly-printed photographs and low-relief moulds were very early developments in the 19th and early 20th centuries.

The first person credited with making permanently fixed images using a camera was (Joseph) Nicéphore Niépce in 1827. He exposed a light-sensitive coating on a zinc plate through a translucent original engraving. The plate was subsequently etched and several prints made.

In 1854 Lafon de Camarsac printed a photographic image on a ceramic surface using a gum system. Potassium dichromate, a light-sensitive chemical, was mixed with gum arabic and a sticky substance like honey then coated onto a ceramic surface. The gummed film was exposed through a positive transparency, and became fixed in the areas where most light hit the surface. By contrast, darker, greyer areas retained a proportionately sticky property in relation to the amount of light received. The result was a latent photograph, only revealed when the ceramic pigment was dusted onto its surface. Where the gum hardened, no pigment adhered, but the darker, sticky areas retained pigment in proportion to their stickiness. Carmarsac also developed a system with ceramic pigment pre-mixed into the light-sensitive emulsion and by 1868 was marketing a system for producing photographic portraits on porcelain. These were

Lucifer, Brown Pet Cemetery, Columbus, Ohio, 1974. Photographic image on enamel made by the J.A. Dedouch Company, Chicago. The company made photographic enamel plaques from 1893 to 2004. 'It was a gum bichromate process, where light tones were "pounced off" with cotton under glass. The black and white plaques were finished without colour. The sepia ones were hand-coloured, with overlays of china paint airbrushed or painted on. It took a year to train a person to match the colours in an original photo. A skilled painter could finish four coloured plaques in a day. The artists wore intense magnifying lenses in front of their glasses to see the intricate details.'[6]
Photo: Mary Jo Bole.

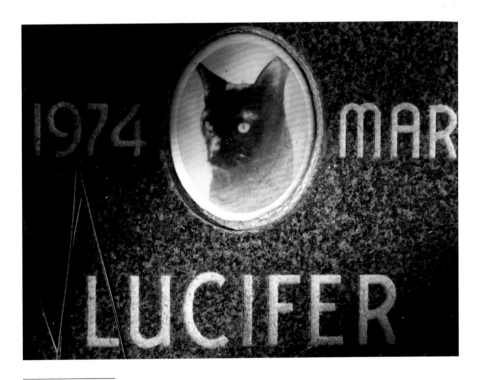

6 Bole, Mary Jo from *Morbid Curiosity*, issue 8, 2004.

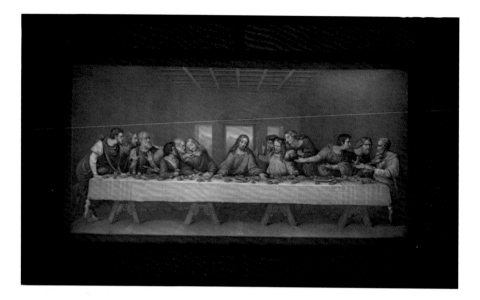

Das Abendmahl, nach Leonardo da Vinci (The Last Supper, after Leonardo da Vinci), German, 19th century, KPM 321 N, Blair Museum acc. no. 478. Lithophane set in stained glass. Ceramics has a long history of appropriating fine art images. Lithophane 14.5 x 28.25 cm (5¾ x 11 in.), stained glass 21 x 34.5 cm (8¼ x 13½ in.). *Courtesy of the Blair Museum of Lithophanes, Toledo, Ohio, USA. Photo: William J. Walker, Jr.*

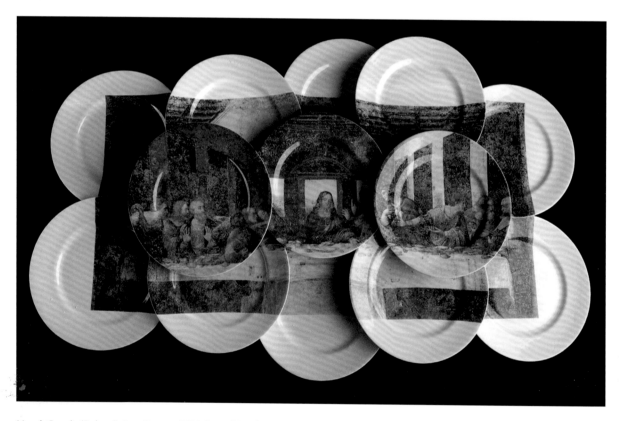

Marek Cecula (Poland), *Last Supper*, 2004. Porcelain plates and digital decals. 'The Last Supper installation is dedicated to the subject of Leonardo da Vinci's fresco *La Ultima Cena* from the refectory of Santa Maria delle Grazie in Milan. A random configuration of 13 porcelain dinner plates, decorated with digitally-printed ceramic decals, is set on a low table.' 70 x 50 cm (27½ x 19¾ in.). *Photo: Sebastian Zimmer.*

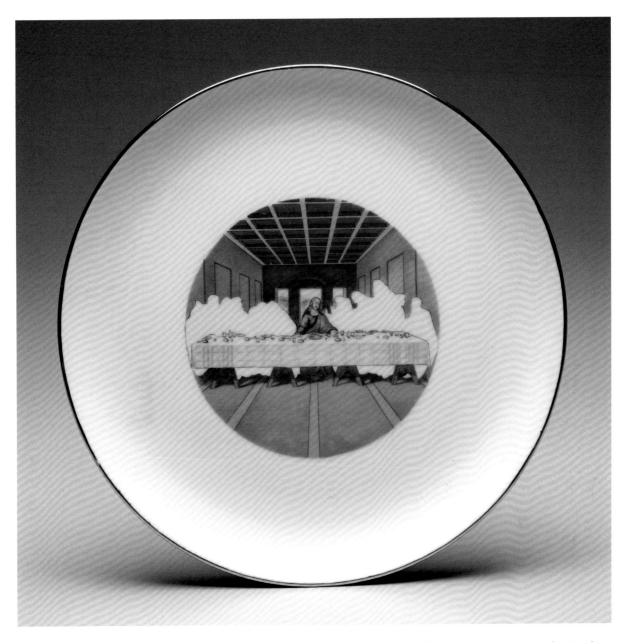

Howard Kottler (USA), *Lost Hosts Ghost*, c. 1967. Porcelain, decals, lustre. Kottler scavenged for ready-made open-stock printed decals from ceramic hobby outlets. Like a number of American ceramists at the time, he first used them on hand-thrown or built stoneware forms, but then began collaging on vintage dinnerware and porcelain blanks, diameter: 25 cm (10 in.). *Courtesy of Paul Kotula Project. Photo: Richard Hensliegh.*

popular in countries with Catholic and Orthodox Christian traditions, in which it became customary to place photographs of the deceased on their graves. Photographs on ceramic and enamel are still common sights in these types of cemeteries. It is possible to order them from specialist manufacturers, although today most are likely to be digitally produced.

In the fevered clamour for new inventions that characterised the last half of the 19th century, several other photographic processes were developed and tried in the ceramics industry. One involved a bichromate process with gelatine in photographic production of relief moulds. Tiles made from the moulds were used in two ways. In the first they were glazed with a tinted, transparent glaze so that where the glaze was deepest the colour appeared darkest and, where thin, the white of the tile showed through. This was an adaptation of an existing relief process where the original artwork would have been created by hand.

Photographic relief moulds were used in another way to produce lithophanes. As with the glazed wares, these were originally created from cast, hand-carved wax moulds to create small, luminous light screens of extraordinary beauty. Unassuming and puzzling without light, they magically transform when illuminated from behind.

CURRENT INDUSTRIAL USES AND DEVELOPMENTS

Screenprinting, lithography and, increasingly, digital processes, now dominate the ceramic printing industry. Scanned images, digital photographs or artwork can now be printed onto laser decal paper in vitreous colour. Personalised products and services have reappeared as part of industrial production. In other developments, 3D printing produces fully-formed ceramic objects directly from the digital printer.

Synthetic media based on hydrocarbon solvents have made many things possible. High-tech machinery and equipment are capable of huge production runs with exacting colour matches. New inks make it possible to reproduce an extraordinary range of colours in ceramic. In response to the health and safety and environmental problems of solvent-based products, new ultraviolet (UV) curing media have been developed. The old glue bat process of transferring colour and designs to ware has been resurrected and refined. Pad printing is a process that involves screenprinting and offsetting, by which silicone pads or 'bombs' transfer flat, printed images from glass surfaces to curved ceramic surfaces. The most recent printing developments involve full-colour digital systems and 3D technologies, realising ceramic objects in the printer. These have immense value to industry for prototyping and product development.

At a time of technological advancement, older processes are gradually disappearing, with a few niche producers (Burleigh and Portmeirion in Stoke-on-Trent, for example) making copperplate-printed tissue wares of very limited patterns. Spongeware has enjoyed something of a revival due to the ever-recurring urban fantasy of rural idylls and simple, rustic tablewares.

The modern ceramics industry in the West has jettisoned its industrial craft skill base, either using more and more automated robotics or outsourcing production to

'developing' economies. There is little room for, or evidence of, human activity in mass-produced wares of the 21st century, but it hasn't always been this way. Examining old printed wares reveals intriguing narrative objects with a human touch. They form part of our cultural wallpaper, familiar yet open to reinterpretation. Technically, older processes offer opportunities for exploration and adaptation for small-scale production, as well as for creative appropriation.

Palisy Pottery Thames River Scenes, View Near Hurley Berks (detail), 1948–56. Underglaze transfer on small bowl, showing the join of the cut tissue print on the border. Diameter: 10 cm (4 in.), from the author's collection. *Photo: Paul Scott.*

Mel Robson (Australia), from a series titled *Re:collect*, 2004. Overglaze decal on slip-cast porcelain forms. Robson's straight cut lines in collaged decals draw attention to the nature of the pattern transfer, referencing industrial print applications. They also show the hand of the maker in the creation of a delicate 'one off' porcelain object, 6 x 5 cm (2¼ x 2 in.). *Photo: Rod Buccholz.*

STUDIO PRACTICE

Artists began to explore the creative potential of printing on paper on a commercial and creative basis from relatively early days. Painters also started to explore the possibilities of ceramic form and surface during the late 19th century, but print only entered the arena when Sam Haile experimented with screenprinting on clay at Alfred University, USA, in 1940. Picasso later explored the potential for printing linocuts in clay at Vallauris in the 1950s.

The reasons for the late experimentation of print with ceramic are partly technological. Until the late 20th century, print effectively developed alongside and within industrial production. In addition, ceramic practices and traditions have almost always involved the appropriation of fine art images. Illustrative Italian maiolica and Delftware simply remediated engraved reproductions of paintings. Graphical ceramics were almost always viewed as an artisanal trade, excluded from the definition of the fine arts studied in the academies.

As well as historical factors discouraging the exploration of ceramic printing, the growth of the studio pottery movement in the UK did little to encourage it. Part of the reason for the lack of knowledge and information in books was because British studio pottery developed from the Arts and Crafts movement, which was fundamentally opposed to industrial material and process. Print was anathema to many potters, philosophically and aesthetically incompatible with their ways of working. Marks (preferably poured glaze or painted oxides) on ceramic surfaces were simply a decorative adjunct to form. Typical was Bernard Leach's view in *A Potter's Book*, that 'well-painted pots have a beauty of expression greater than pottery decorated with engraved transfers, stencils or rubber stamps'. His only other references to printing are equally disdainful, with stamps being dismissed out of hand as 'vulgar patterns, and mechanised shapes and finish, the effect is deplorable'.[7] It is, of course, not a particular process that leads to good or bad work, but rather the way a technique is used, or the context in which the work is made or exhibited, that are the key factors. A pot that is sponge-decorated isn't automatically mechanical and lifeless, much as a painted pot is not automatically beautiful and expressive. As importantly, print on or in the ceramic surface need not be on a three-dimensional form.

Leach also wrote that printing on ceramics was 'a further stage in the division of labour, which, however necessary for mass production, has destroyed the unity of conception and execution in the completed article'. However, by the time print had become incorporated into the industrial process the mass production of pottery had already ensured that the making of ceramic forms was divided into specific tasks, and the 'unity of conception' had already been destroyed. Although the Industrial Revolution did allow for ceramic production on a huge scale, with the division of labour and skills, pottery production itself was one of the first manufacturing processes to be industrialised, centuries before. Processes of preparation, throwing,

7 Leach, B 1967, *A Potter's Book*, Faber and Faber, London (p. 101).

Sasha Wardell (UK), *Slip-cast Form*, 1979. Semi-porcelain with screenprinted overglaze print. Wardell's slip-cast forms are a good example of the artistic use of industrial mass-production techniques. Wardell consistently uses slip-casting to produce work in which a degree of repetition is possible (the form), but the development of surface line and pattern is unique to each piece, height: 20 cm (7½ in.). *Photo: courtesy of Sasha Wardell.*

decorating and firing were easily identifiable and separated, so specialist tasks could be the exclusive domain of trained craftspeople. In Crete, ceramics from Minoan and Mycenaean civilisations clearly show that pottery was produced on a vast scale, in some sort of industrial way.[8] Vast numbers of crude drinking cups found at Mycenaean archaeological sites suggest the first disposable cup. Throwing clay to make functional forms was the start of industrialised pottery-making, so it is ironic that the association with industry should keep printed ceramics outside the accepted norms of studio ceramics. Throwing, casting, jigger-jolly, dry press-moulding and graphic print processes are all designed for commercial exploitation, but artists have long appropriated these and other techniques for creative expression.

In Scandinavia and Eastern Europe, closer links between studio practice and industry were based on a degree of mutual respect, understanding and dialogue, so much so that artists' studios were provided in factories like Royal Copenhagen, Rörstrand and Gustavsberg. These gave artists working spaces, and left them free to use the factory's materials in innovative and exploratory ways. Some also became involved in product and surface design.

8 Personal communication with Vronwy Hankey, 1994.

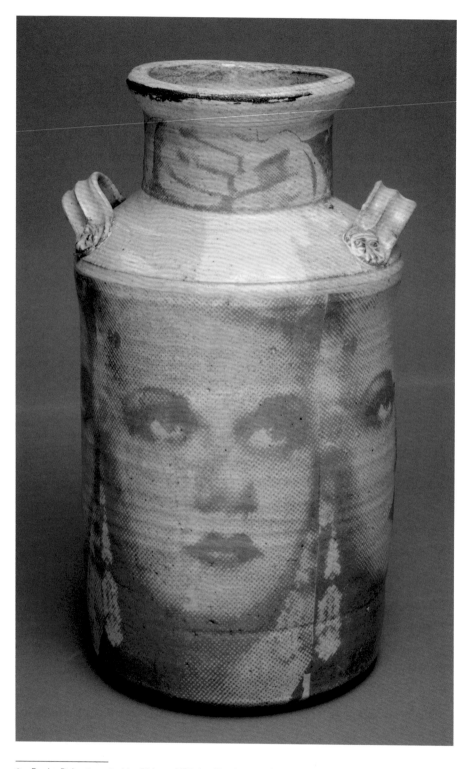

Robert Engle (USA), *Harlow Pot*, 1968. Glazed stoneware, fired decals. Originally shown in the Objects USA exhibition. Engle taught photography as well as ceramics at Ohio Wesleyan University. He wrote, 'I am not interested in pots which are simply pleasant to live with … I feel that Pop is the best thing that has happened to art in the last 250 years. It has pulled art out of the rare atmosphere of the artist's world down to the blood and guts of everyday living … We have grown up to a point where mass culture is accepted and we are no longer worried that the IBM machine will take over. Pop art rejoices in man's ability to use the computer. The craftsman is still behind the painter in his acceptance of industry. Still hung up on William Morris's fears of the Industrial Revolution.'[9] The form makes clear reference to the handmade, the potter's hands throwing the urn, but provocatively juxtaposes the industrial screenprint – Jean Harlow's image (a direct reference to Warhol's Marilyn Monroe) on the stoneware form. Museum of Arts & Design, New York, gift of the Johnson Wax Company in 1978 through the American Craft Council, 39.4 x 21.6 x 24.1 cm (15½ x 8½ x 9½ in.). *Photo: Ed Watkins.*

9 Engle, Robert quoted in *Objects USA*, Lee Nordness, Thames and Hudson, 1970, p. 106.

Liv Midbøe (Norway), *Work in Progress*, 2007. Wheel-thrown terracotta, porcelain slip, transparent lead glaze, with laser decals. 'In a globalised world of industrialisation, the production process of objects around us tends to be more abstract or remote than before. This series of wheel-thrown pots play with the sensuality and beauty of a potter's work. Containing their own history, they freeze at the moments of how they came into existence and are self-referring to their own origin.' Held in the collection of the West Norway Museum of Decorative Art, Bergen, 7 x 15 x 15 cm (2¾ x 6 x 6 in.). *Photo: Ole Kristian Justnaes.*

Jennifer Anable (USA), *Cup*, 2003. Wood-fired cup with low-fire overglaze commercial decals, made at Guldagergård, the International Ceramic Research Centre, Denmark. Whilst the juxtaposition of decal with a stoneware thrown form was controversial and revolutionary in 1968, Anable's delightful explorations of functional form and decorative device were much less likely to offend by 2003. Height: 14 cm (5½ in.), from the author's collection. *Photo: Paul Scott.*

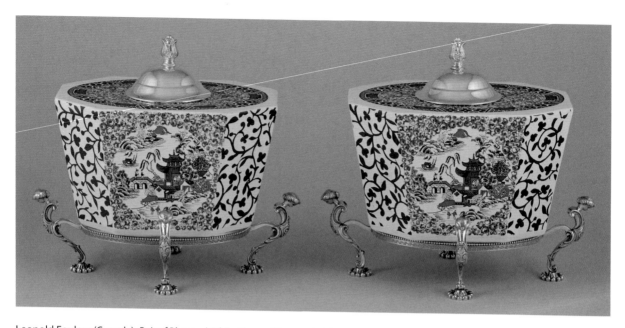

Leopold Foulem (Canada), *Pair of Blue and White Covered Tureens in Silvered Mounts*, 2006. Ceramic and found objects, height: 25.5 x 29 x 22 cm (10 x 11½ x 8½ in.). *Photo: Richard Milette.*

In North America, although the Leach influence was strong, other forces were also at work. In the post-war years, a culture unfettered by centuries of tradition and academic practice produced Abstract Expressionism and Pop Art. These visual arts movements transformed studio ceramics practice. The West Coast of the United States spawned Funk and the Super-Object, leading to a much greater diversity of work in clay. The resultant objects were much in evidence in *Objects USA*, a seminal exhibition featuring materials collected by the S.C. Johnson & Son company, which toured throughout the USA at the end of the 1960s and early '70s before travelling to Europe.

Recent years have seen radical change sweeping through studio ceramics, along with a much greater openness to change. This has come about because of an increasing exposure to ceramics from around the world, though the web and international magazines like *Ceramics: Art and Perception*, as well as a dissolution of material disciplines in higher education. Today, industrial process and debris provide the new, raw materials for artistic narratives.

Traditional studio pottery has virtually disappeared from art schools and universities. Ceramics has often been subsumed into fine art and design departments, or opened up to them. Clay is viewed as another medium for contemporary artists. In some quarters there is concern about the loss of craft knowledge and skill as a result of these changes, but the contemporary diversity of practice suggests that the skill base is changing rather than disappearing.

10 Peterdi, G 1980, *Printmaking*, Macmillan, London (p. xxvi).

There is an increasing recognition of the traditions and potential of print in ceramics. Contemporary practice is now diverse and interdisciplinary. Some of the artists featured in this book are not wedded to a material as their main medium. Some who do specialise in ceramics have come from other disciplines, transferring and adapting skills and techniques to a different medium. In so doing they have created new methodologies and material connections.

Gabor Peterdi, in the introduction to his comprehensive manual *Printmaking: Methods Old and New*, explains the material reasons for his engagement with printmaking: 'I make prints because in using the metal, the wood, and other materials available, I can express things that I cannot express by any other means. In other words I am interested in printmaking not as a means of reproduction but as an original creative medium. Even if I could pull only one print from each of my plates I would still make them.' For others, the conceptual possibilities of artistic intervention in industrial products drive the creative engagement.[10]

DIVERSITY

The artistic use of ceramics and print means that work is produced in many different contexts. Potters produce functional domestic ware with complex printed surfaces, whilst artists like Robert Dawson (UK), Grayson Perry (UK) and Leopold Foulem (Canada) subvert the traditions of ceramic decoration and our perceptions of them. For contemporary artist Conrad Atkinson (UK) the print's value on his plates, depicting ceramic land mines, water closets and sinks, is not primarily in the skill of application, or execution, or in the beauty or otherwise of the object that supports it, but in the context in which it is used and viewed. For Atkinson, 'the medium has always been inextricably linked to the purpose of the work, and never its reason for being.'

Whilst attitudes to processes may be different and individuals draw on different traditions, they still use common materials and ceramic processes.

Robert Dawson (UK), *Spin*, 2010. Digital prints on a set of six bone china dinner plates, diameter of each: 27 cm (10½ in.). *Photo: courtesy of Robert Dawson.*

Spin

Spin, turn, revolution, throw, rotate, orbit, jigger, jolley, around and around.

And around and around.

Spin, wheel, whirl, twirl, gyrate, circle, Campbell, twist, swivel, pirouette, pivot, thirty-three and a third, PhD, 'til the moon went down.

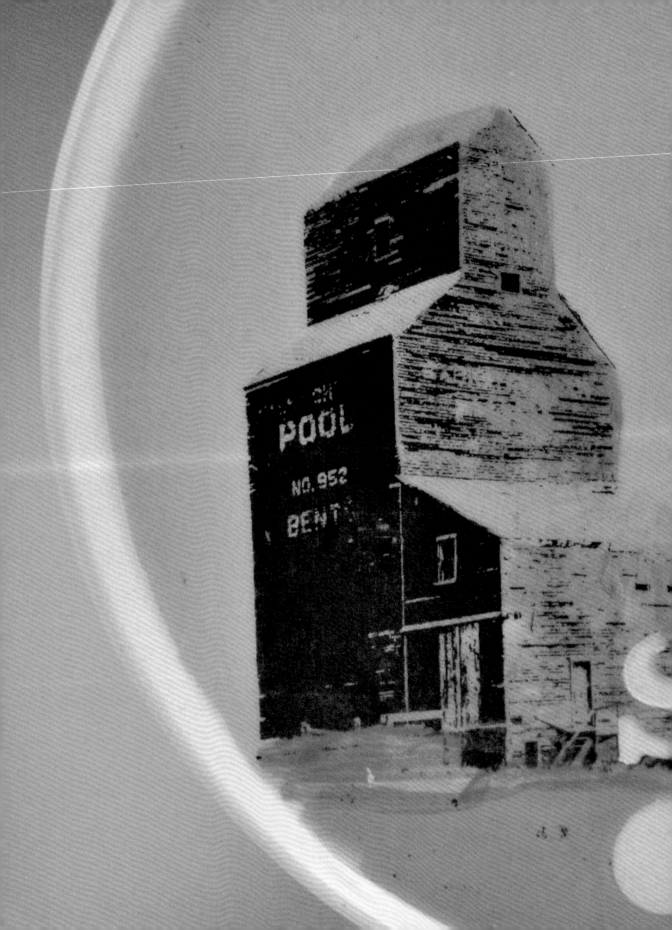

2

Colour transfer media and ink – the basics

When the famous Spode factory in Stoke-on-Trent was still functioning, you could take a 'connoisseur' tour around the site to observe the whole process of making. In the decorating section, you would see a range of specialised traditional craft skills being employed: the printer painting a thin sheet of pottery tissue with a dilute solution of soft soap before turning to smear a warmed, chrome-plated engraved copper plate with underglaze ink. Quickly working the mauve, viscous 'potter's tar' into the cut and stamped lines with a flat edge, he would clean the surface swiftly with a steel blade. Within a few seconds the inked copper would be on the press, soaped tissue face down on the plate and felt blanket on top, before disappearing under, then out from, the printing press roller. With the felt pulled back, the tissue steamed, the printer then peeled an extraordinarily detailed graphic off the copper plate.

The oil-based print, stuck to the soaped surface of the tissue, was handed to the first female worker (printers and engravers were always men, the decorators always women). Using a glass cutter she would draw smoothly and fluently around the pattern, cutting the differing elements out from the background, before handing them on to the next lady in the line. The sticky print was then precisely placed, face down, onto the high-fire bisque wares before being thoroughly burnished with a stiff bristle brush. Once completed, the ware, with a paper-coated surface, was passed on once more, this time to be gently rinsed. Water soaking into the tissue softened and dissolved the soap, releasing the paper, leaving the printed graphic stuck to ceramic surface.

This relatively sophisticated transfer system was used for over 200 years to decorate industrial tablewares. It embodies very basic principles of image transference, lifting a graphic from one surface onto a flexible substrate, which in turn is pressed onto the ceramic – raw, dry bisque or glazed. The material mechanism of transferring pattern or drawing varies according to the state of the ceramic surface.

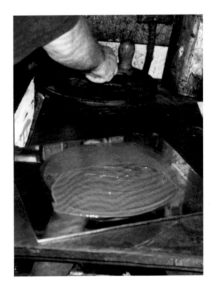

Printer removing ink from an engraved plate with a steel scraper in the Spode Factory, c. 1998. *Photo: Paul Scott.*

Cathy Terepocki (Canada), *Elevator Plate*, detail from *Seconds: Images from an abandoned town,* 2011 Monoprinted plate, imagery screened onto plaster mould then slipcast. *Photo: courtesy of Cathy Terepocki.*

COLOUR

Because vitreous surfaces are created by firing and the action of heat, most ceramic prints are made with inks that are particulate. These are powdered pigments derived from metal oxides, suspended in some kind of medium. Often favoured by potters for their unpredictability, raw oxides such as cobalt, copper, iron and manganese are the most elemental types of colour. By contrast, the ceramics industry, more interested in consistency, uses oxides in more stable forms by pre-mixing them with high-temperature fluxes to create stains. These intense, hard colours are used to stain clays, slips and glazes. They are further fluxed with different-temperature glassy frits to create underglaze colours melting from 1050°C (1922°F), china paints, enamel or overglaze colours melting from 850°C (1562°F), and glass colours from 550°C (1022°F). In Britain and some other parts of Europe, all these kinds of powdered, ready-fritted colours are available from ceramic suppliers. In North America there is a 'Mason stain' powdered system. This involves the user mixing pigment (stain) with appropriate frits to create their own under and overglazes. More common are ready-mixed underglaze colours sold in liquid form, extended with finely-ground clays and media, and marketed as a painting medium. They attempt to mimic the many conventional colours and inks used in painting, printmaking or textiles studios, many of which today are dye-based, dissolved colours in water-based media. Ceramic colours that are not particulate include precious metal lustres. These are dissolved in acid and suspended in solvents.

In this book emphasis will be placed on using powdered colour because, with the virtual absence of any readily-available manufactured ceramic inks, it allows the most flexibility for the artist.

PRACTICE

In nearly all of the following processes it is important to realise that there is no substitute for practice and experience. In a sophisticated, digitally-enabled world, we are used to obtaining remarkable, perfect results on paper from our printers at the press of a keyboard button. In choosing to engage with raw materials and the alchemy of fire, readers must appreciate that the perfect print is rarely achieved first time around, so it is important that when trying to work with a new process, you maximise your chances of success. My advice is to work on a small scale with strong bold graphics to master a technique, before attempting the complex, multi-coloured, delicate tonal work you really want to do. Do not invest hours working on a detailed drawing or Photoshop file before you have the mechanics of production working and understand them. Work with simple marks and lines, then begin to understand the materiality of ink, medium, transfer substrate, clay or glaze by repeating small prints. Spend an hour repeat printing a small basic design in any technique and you will learn a vast amount. It is unlikely that you will be able to verbally articulate exactly what you have learnt, but you will have acquired tacit knowledge – understanding that is

stored in your eyes, fingertips, hands, arm muscles, and a sensitivity to the tools and materials you are using that cannot be explained to yourself or others.

The following descriptions of material, media and surfaces outline the process from the simplest water-carried powder transfer to solvent-based decal systems, thence to the digital and photographic. The aim is to provide a backdrop to the subsequent chapters, which will examine specific process and material combinations. Understanding basic principles allows invention and exploration.

POWDER PRINTING

A transfer, in its simplest form, involves the use of ceramic colour suspended in water. This is brushed onto a glass sheet or glazed tile and allowed to dry. A piece of paper placed on top of the dry colour will remove pigment from any area subject to pressure – a drawing, for example. This can then be transferred by placing the paper onto a damp clay surface.

The powdered layer on the glass can also be lifted off using other matter, such as leaves, flowers, rubber or silicone stamps. In this case the soft surface picks up the pigment from the hard, shiny one, depositing most of the colour onto wet or damp clay with ease. With experience, a remarkable graphic fidelity can be achieved using just these basic materials.

A more direct transfer can be created by directly painting paper with pigment suspended in water, once dry rubbing the paper face down on damp or wet clay transfers the print.

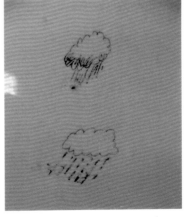

Glass sheet showing evidence of powdered colour having been being lifted off on paper and rubber stamps.

Simple, drawn, powder monoprinted clouds transferred to a dampened glazed surface.

DUSTING

Another important series of graphic processes involves dusting dry pigment onto wet printed surfaces. These can be water-based, in the case of new inkjet techniques, oil-based in the case of bat prints from engravings, or photographic, as in gum bichromate processes.

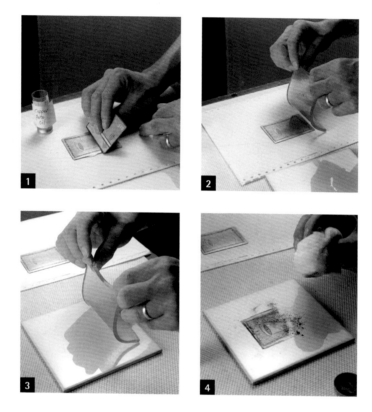

1. Inking an etched zinc plate with oil.
2. Picking up latent oil image with gelatine pad.
3. Transferring oil image to glazed tile.
4. Dusting tile with ceramic pigment to reveal image.
Photos: Andrew Morris.

SLIPS AND ENGOBES

Adding liquid clay to dry ceramic colour instead of (or as well as) water creates different print possibilities. Different slip/engobe colours can be bought ready-mixed from ceramic suppliers; they tend to be very finely ground. They are also easily made in the studio by adding oxides or stains to liquid clay. It is best to first mix with water so the colour is already suspended in liquid form.

Slips have a natural affinity to plastic or leatherhard clay, because they are basically the same material, but with more water. The wet/dry process that is key to the deposition and transfer of powdered colour is in action when printing with slips, but the clay also acts as a binder, so different mechanisms must be employed to print. In order for the transfer process to work properly in this case, slips must be employed on an absorbent surface like newsprint or plaster.

Splashed slip-based colours on newspaper being transferred to damp clay.
Photo: Paul Scott.

SCREENPRINTING, INTAGLIO, RELIEF AND LITHOGRAPHIC INKS

Ink mixing is best done on a large sheet of glass or glazed (glossy) tile using two good palette knives.

There are very few readily-available inks on the market for printmaking. Mixed underglaze colours, sold in liquid form in North America, have been adapted by artists for screenprinting and other purposes – sometimes with the addition of corn syrup or CMC (cellulose gum) to thicken and render the colour more manageable. Even so they require some working to enable fluent printing, and it is much easier to use materials specifically designed for printing purposes. In the case of serigraphy, ceramic suppliers usually stock oil-based screening media for use in conventional decal making. Over time these oil-based systems have become less and less popular because they are unpleasant to use and solvents are needed for cleaning. A number of branded acrylic substitutes specifically designed for the purpose can be used in their place. In Europe, these include Rowney System 3 and Lascaux, while in North America there is Speedball, among others.

In recent years, in response to environmental as well as health and safety issues with oil-based systems, print studios in educational institutions have moved over to water-based screen processes. Products like Rowney System 3 screenprint medium are used to extend ready-prepared inks, slowing their drying time and allowing colour dilution or greater transparency. Used with powdered ceramic pigments, the acrylic readily absorbs colour, creating an ink of yoghurt-like consistency that works very well, is good to handle and cleans up easily. Ratios of powder to medium depend on

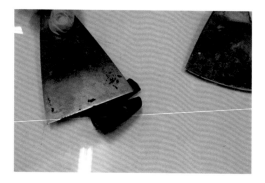 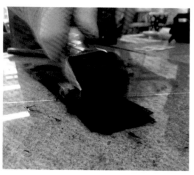

Oil-based ink mix showing cleaned glass, before
the addition of lighter oil to let the mixture down.
Photo: courtesy of Paul Scott.

Oil-based ink, let down
with light oil and rolled out.
Photo: courtesy of Paul Scott.

the colour itself (oxide, stain, underglaze or onglaze) and the purpose of the print. Direct screenprints on clay intended for wood, salt or soda firing for example require much less density of pigment than those on ready-glazed surfaces.

For intaglio, relief and litho inks, powder is mixed with media appropriate to the technique, so a good block-printing ink can be made from medium plate oil, 'let down' (made more fluid) with linseed oil; intaglio, by using transparent base; and litho ink, by using litho varnish. It should be easy to find plate oil in the printmaking studio. It comes in three grades – heavy, medium and light. Always make ink using heavy or medium oils. An alternative is stand oil – a similar polymerised linseed oil – available from most art shops that sell oil paints. Other suitable media include transparent base, or base extender, as well as litho varnish. A glass muller may also be useful for mixing oil-based inks well. If you intend to use water-washable inks, then use the appropriate base. In each case, mixing the ink requires some patience, as it is extremely important to saturate the main medium to create an almost dry, very dense mixture. Again, exact proportions of colour to medium can only be defined after experimentation; different colours and types of pigment will behave differently. Your initial mixture should be almost dry – you should be able to clean the glass mixing plate, picking up powder and cleaning smears of oil, with the lump of colour you create. The thick colour mix should be let down by adding small quantities – drop by drop from a pipette or a stick dipped in linseed or light plate oil – to the required consistency. In the case of a relief-printing ink, you should be able to roll it with appropriate tackiness. For etching or engraving, the ink will be stiffer, as it is often applied on a hot plate. Litho inks should be easily rolled but shorter, so less inclined to smear or stretch.

Creating a saturated, thick, dry material before letting down is crucial to the success of the ink. In all cases, the actual thickness of applied colour is very slight, and with particulate pigment it is absolutely essential to load the original medium so that it cannot absorb more powder. All these inks will benefit from an overnight rest and will function more efficiently if prepared in advance.

Unused ink should not be wasted and can be saved in an appropriate, airtight container; it is important to exclude air when storing. A simple, cost-effective way to

do this is to use sticky packing tape. Place the ink carefully in a sausage shape onto the centre of the sticky side of a rectangle of tape (if necessary made from several overlapping pieces). Then carefully fold the tape to enclose the ink, taking care to exclude all the air, label the resulting 'tube'. To use the colour again simply cut off one corner of the 'tube' and squeeze the ink out.

In many cases it is perfectly feasible to print directly on clay, paperclay, bisque or a glazed surface. In other circumstances, where the print needs to be used on a three-dimensional form, it is necessary to create some sort of transfer so that the graphic can be wrapped around/inside the dry or fired form.

TISSUE AND PAPER TRANSFERS

Possibly the simplest paper transfer process has already been described at the start of this chapter, and it works with a wide range of different papers. For many years the industry standard material was pottery tissue, a fine, thin, strong substrate, not unlike cigarette papers. With the demise of industrial tablewares in Europe and North America this has become increasingly rare. Fortunately, other fine thin tissue papers are available, and in many circumstances substitutes like newsprint, are in fact superior, especially where some absorbency is desirable.

Ready-printed tissue transfers from China are now increasingly available. These have water-based screened patterns on their surfaces; applied to wet or damp clay and rubbed down, they will transfer almost immediately. Dry clay or bisque must be wetted first, but the method is similarly effective on these surfaces.

Using water-soluble acrylic print media on any paper substrate creates a similar type of transfer that can be stored indefinitely. These work almost immediately when just printed but require longer contact with the wet or damp clay surface once the acrylic has cured.

DECALS

Decals are a relatively simple and flexible way of putting print onto a ceramic surface. They can also facilitate the application of complex, precise and multi-layered prints. Ready-printed, open stock decals can be bought from ceramic printers or from eBay.

Traditionally, decals are made by printing (lithograph or screening) an image or design in oil-based ceramic inks onto a specially-gummed decal paper. The paper, with its printed design, is then coated with a liquid lacquer or varnish called covercoat, which on drying becomes a thin plastic sheet including the graphic. For individual sheets, the lacquer can be applied by using a plastic credit-type card to pull a thin layer across small prints; however, it is preferable to apply by squeegeeing through a blank, relatively open silkscreen. Covercoat should only be used in well-ventilated (preferably air extracted) areas, and users should wear a suitable solvent vapour

mask. Prints also need good ventilation as the vapours are potentially explosive if contained. Screens have to be cleaned with thinners.

When dry, the decals are ready to use. Placed in warm water, the plastic sheet with the print becomes moveable, and is slid off the gummed paper to be positioned on a glazed ceramic surface (glass or enamel work too). Once on the glaze, the decal can be slid around until correctly positioned, then firmed into place with a rubber kidney or by rubbing with a finger, ensuring that no pockets of air or water are trapped below the covercoat surface. The residues of the gum help the transfer to adhere. On firing, the plastic burns cleanly away, leaving the printed image or design on, or in, the ceramic surface.

Covercoat lacquer is problematic to use in the studio and in communal workspaces because of its high solvent content. Cleaning the screens used to apply the varnish requires the use of cellulose thinners that are unpleasant to use, potentially explosive in vapour form and environmentally dubious. Naturally, over the years artists have sought out alternative products, discovering a range of spray lacquers and other substitutes. Rimas VisGirda has done a series of tests on different proprietary brands in the US. Whilst these may be more convenient to use than screening covercoat for isolated prints, most are not preferable on an environmental level as cans of spray lacquer usually require solvent propellants. Spray lacquer also has a tendency to become brittle over time, rendering decals virtually unusable after a relatively short time in storage.

However unpleasant it is to use, covercoat has been specially designed to lift an image off gummed paper in water, be flexible on application to glazed ceramic surfaces and, most importantly, to burn out cleanly without distorting the printed image on firing.

In the past few years a number of new transfer papers have become available. These were initially developed to make use of digital printing technologies, which allowed industry to make mock-up designs and apply them to wares instantly. This removed the need to make up screens or lithographs, and allowed immediate assessment of new pattern designs. Several types of pre-coated decal paper are available from a number of manufacturers. These products are specifically produced for particular methodologies and technologies, and experimentation with them outside their intended use should only be undertaken with extreme care.

These new decal papers have opened up a variety of options for artists in different media, but for ceramics their uses are two-fold. Firstly, some of the pre-coated papers are suitable for mono-laser copiers, which contain iron oxide in their toners. This means that with a computer, the right printer and the appropriate decal paper, sepia

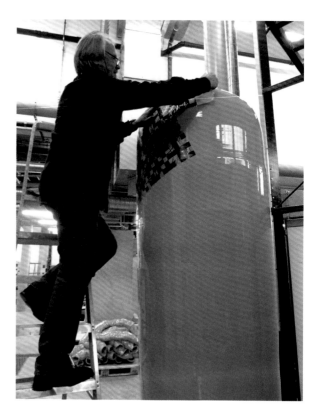

Ole Lislerud (Norway) applying decals to a large porcelain vase at Oslo National Academy of the Arts. The covercoat lacquer is yellow and will burn away during the firing, leaving the black graphic in the glaze. *Photo: Paul Scott.*

ceramic prints are available at the click of a mouse. The second use of the paper involves the printing of oil-based or other waterproof media to create usable decals without the need to use evil-smelling covercoat.

Different acrylic products, printing media and acrylic glaze or varnish can be mixed so that the finished print is waterproof on drying. By printing this mixture (with pigment) onto pre-coated transfer paper it is possible to make alternative ceramic decals without touching the problematic lacquer. Exact proportions of media, acrylic glaze and colour vary according to manufacturer, printing conditions and the purpose of the print. Some artists use acrylic varnish solely with pigment for waterproof ink, while others pre-mix it with varying proportions of printing medium or extender. In hot, dry conditions, more extender is advisable to stop screens from blocking during printing. Finished decals need time for the prints to cure, although they can be used almost immediately if the transfers are carefully back-sponged, face down on paper towels, rather than being fully immersed in water.

The print in this case is now on top of the covercoat which has to burn out from under the graphic on firing. For line and fine detail there is seldom any problem, but solid blocks of colour may have some holes where the burning lacquer has forced its way through.

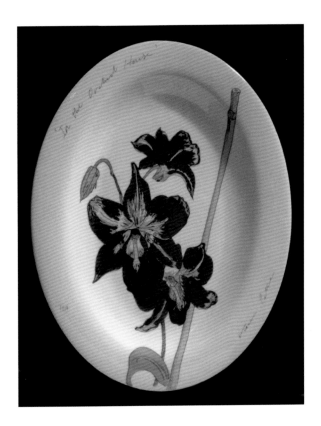

Kevin Petrie (UK), *In The Orchid House*, 1998. Water-based screenprinted transfer on bone china, private collection. Petrie developed the commercially available U-WET water-based decal system, which uses pre-coated decal paper, during research at the University of the West of England, longest dimension: 35 cm (13¾ in.). *Photo: Kevin Petrie.*

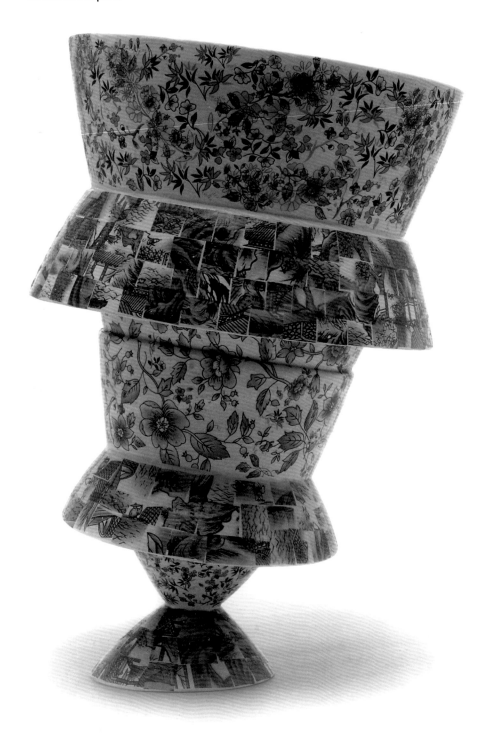

Kris Campo (Belgium), *Trias Green*, 2009. Thrown, assembled form with engobes and Chinese tissue/film transfers, 27 x 16.5 cm (10½ x 6½ in.). *Photo: Philippe van Nieuwenhove.*

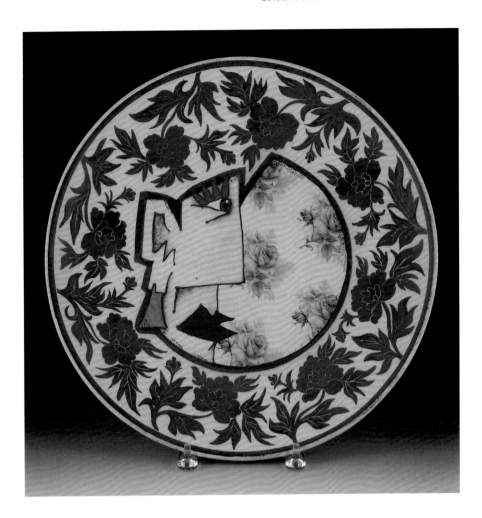

Rimas VisGirda (USA), *China girl*, 2011. Jiggered Jingdezhen porcelain, black underglaze, glaze, decals, overglazes, gold lustre. VisGirda's graphic surfaces are often a complex mix of open stock decals in conjunction with drawn, sgraffito, painted details and handmade decals in a variety of different ceramic media, diameter: 40 cm (15¾ in.). *Photo: Rimas VisGirda.*

CLAYS AND ALTERNATIVE VITREOUS PRINTING SURFACES

It is quite easy to print on clay in all its forms – wet, leatherhard, dry, bisque, high fired and glazed. Hybrid materials that are also useful for printing on include paper-clay and industrially-produced Keraflex, a flexible film made of porcelain and organic binders.

Paperclay is a compound of paper pulp and clay, which has incredible green and dry strength. Upon firing, the paper pulp burns away with no significant effect on the body or surface. Making paper pulp is relatively easy. Cotton linters and highly-absorbent blotting paper are ideal. Their long fibres mixed with porcelain slip can make excellent clay sheets suitable for etching, screen- or block-printing. Although sculptors have made pulp for paperclay with everyday alternatives such as paper towels and photocopy or laser paper, these do not make good material for printing on.

Spreading paper porcelain sheet on plaster block. Guides are used to ensure an even thickness of paperclay. *Photo: Herbert Wiegand.*

Cutting paper porcelain with scissors. *Photo: Herbert Wiegand.*

To make printing sheets, the paper must be shredded or ripped into small pieces and soaked overnight in water to break it down. After mixing with a blender or glaze mixer, the resulting pulp should be squeezed to remove as much water as possible. To make paperclay, mix one part pulp to two parts slip in a blender or liquidiser. The mixture should be turned into usable paperclay sheets as soon as possible by spreading evenly over a plaster slab, using guides and a straight edge to tamp the material down. Allow the resulting sheet to dry until is is possible to peel it off.

Rachel Kingston (USA), *Chatbox*, 2010. Direct laser print on Keraflex porcelain, 8 x 8 x 5.5 cm (3 x 3 x 2 in.). *Photo: Rachel Kingston.*

The mixture in slop or liquid form does not store well and turns distinctly aromatic after a short time; ideally it should be used within a day or so. It can be bagged and frozen if not all of it is used at once. Dry paperclay (scraps, etc) can be reclaimed like normal clay.

Large, paper-thin sheets of paperclay can be made without fear of warping. The product has incredible green and dry strength, and pieces can be stuck to each other dry, or dry to wet (just using a slurry of paperclay). Bisque and glaze-fired strength is the same as for normal clay, so paper-thin sheets of fired paper porcelain are still extremely fragile.

Keraflex is an industrial material made of powdered ceramic materials mixed with an organic binder. As it is made in thicknesses from 0.5 mm, it has many of the characteristics of 'normal' paper. It is relatively flexible and can be used in a variety of printing presses. There are also a number of individuals and institutions currently exploring the possibilities of direct digital printing on Keraflex. It is important to once-high-fire Keraflex, missing out the traditional bisque firing as the material is extremely delicate in its unfused state.

Finally, any ceramic prints that would normally be applied to glazed surfaces can also be used with enamel or glass, and subjected to appropriate firing.

Stephen Dixon (UK), *Superb Blue Wren*, 2006. Antique enamelware 'found' mug, re-fired to 800°C (1472°F) with screenprinted and open stock decals, 7 x 10 x 7 cm (2¾ x 4 x 2¾ in.). Made at the Jam Factory, Adelaide, Australia. *Photo: Tony Richards.*

Monoprinting

A *monotype* is a unique artwork, usually derived from a drawing process, by which colour and marks are lifted and transferred from one surface to another. Although second prints may be made, they are usually so different in character as to appear unrelated, at best ghost images or very faded versions of the original. A *monoprint*, on the other hand, can be one of a series – a silkscreen print that has been altered by drawing or by the use of individual colourants, for example.

Confusingly perhaps, the process of working with both monotypes and monoprints is called monoprinting. A number of different techniques are possible using ceramic materials.

POWDER MONOPRINTS

A remarkable quality of drawn line is achievable using powdered colour. A sheet of glass or glazed tile is painted with ceramic colour simply mixed with water. When dry, a sheet of paper placed on the glass will pick up the powder where any pressure is applied. Dry drawing with pencil, biro or chalk works well, but stronger colour removal is possible with wet rollerball pens and ink markers. Depending on the type of paper used, the surface can be very sensitive, picking up from drawings done with a cotton-bud or fingertips. It will also pick up unintentional marks from finger or hand pressure. When the drawing is complete the paper should be removed and then placed face down onto a damp clay surface. Gentle, firm pressure should be applied to the paper using a squeegee, plastic card or similar device. Removing the paper will reveal a drawn image transferred onto the clay surface. Different drawing implements will produce a variety of marks and drawn qualities. A pencil line will be quite different in character from a biro or a soft smudge from a finger. It is also possible to monoprint several layers of colour from individually-painted tiles or sheets of glass. It is preferable to use a clean drawing sheet of paper on each one. Photocopies of drawings or photographs can be used in this way to create multicolour monotypes. The drawn image on clay can also form the starting point for further drawn and painted detail.

The receiving surface for the print must have a degree of wetness to it, so dry and bisque wares will need to be moistened. Even more remarkably, the powder print can be transferred to a glazed surface, if the surface is moistened first. For the process to work, the transfer paper needs to have some level of absorbency, so newspaper or newsprint work well. Other methods for working with a glazed surface include

Petra Bittl (Germany), *Object 2*, 2011. Plaster monotype with black porcelain slip on Limoges porcelain, and glass, 1260°C (2300°F) reduction firing with salt, 40 x 20 x 8 cm (15¾ x 8 x 3 in.). *Photo: Thomas Naethe, Bendorf.*

TOP LEFT: Painting ceramic colour onto glass sheet.
TOP RIGHT: Paper applied to dry powder then drawn on. Drawing tools shown on the left.
LEFT: Removing the paper reveals the print.
Photos: Paul Scott.

making it sticky with glue or a sugary material. Achieving competence with these more difficult surfaces is best done after getting the hang of the wet clay transfer first.

The process is simple and does not rely on exacting conditions to work, but oxide and colour should not be mixed with any kind of underglaze medium. This binds the colour too strongly to the glass or tile, and makes an effective transfer very difficult.

Sometimes the negative graphic on glazed tile or glass surface can be regarded as desirable for the finished artwork, instead of (or as well as) the transferred image on clay. Firing temperature for glass or tile needs to be sufficient for the painted colour to

Ceramic colour suspended in water, painted over glossy magazine illustration. Note how the colour sticks to the paper but not the printed areas. *Photo: Paul Scott.*

Henriette Ackermann (Germany), test tile. Powder laser-resist monotype in cobalt oxide on Limoges porcelain with a clear glaze. *Photo: Paul Scott.*

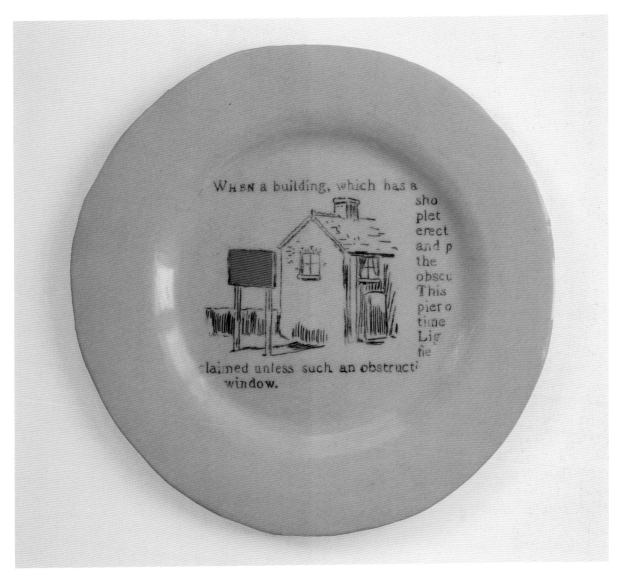

Karen Densham (UK), *Obstruct*, 2012. White earthenware with monoprint and transfer paper. Densham has been working with powder monotypes for many years, developing them on both raw and glazed clay surfaces. She sometimes combines the technique with painting, stamping and collaged decal colour. Diameter: 35 cm (13¾ in.). *Photo: Terry Bond*.

fuse, so stains, underglazes and oxides will require the glassy material to be softened for the colour to sink in.

Painting the same ceramic colour/water mixture directly onto glossy papers, photocopies and laser prints produces imagery and graphics dictated by the printed paper surface. Glossy inks repel water whilst the unprinted paper surface absorbs it, and the suspended colour. The result of ink/toner resist is another simple monoprinting methodology, which can be exploratory or very deliberative.

Fiona Thompson (UK), *Flattened Vessels*, 2000. Hand-built earthenware, brushed and monoprinted slips transferred from newspaper, and matt glaze, 25 x 23 x16 cm (9¾ x 9 x 7 in.). *Photo: Fiona Thompson.*

PLASTER MONOPRINTING

Plaster, the white absorbent material so important for slip-casting and press-moulding in ceramics, is also an ideal material from which to monoprint. To do this, powdered pigment must first be mixed with slip.

A slab of plaster cast off a glass sheet provides the perfect transfer platform for painted, drawn and sgraffito graphics created in coloured slips. The monotype is removed by pouring casting slip over the artwork, leaving it to firm up before lifting it off. This can be made easier by blowing compressed air between the clay slab and plaster after an edge has been lifted. Alternatively, a rolled out clay slab, wetted and brush-worked so that it has a slip-like surface consistency will also work well. Printed slabs can then be used as tiles or built into forms.

Drawing into the plaster with a sharp tool produces an engraved line. Prints taken from this kind of surface can be defined as intaglio monoprints. The process can be used on forms and moulds as well as flat smooth plaster slabs. Drawn lines are filled with slip then scraped back with a stiff plastic card. Painting and infilling the design with contrasting slips produces a characteristic graphic quality when the print is lifted off slab or out of mould.

Elke Sada (Germany), *Capriccio,* extra-large bowl, 2011. Vessel made from slip-painting, earthenware and transparent glaze. 'Brush strokes. Fields of colour. Drops fall from brush. Scratch runs through. Lines go up and down and around.' Diameter: 31 cm (12¼ in.). *Photo: Michael Wurzbach.*

CLAY MONOTYPE

In a curious reversal of ceramic print practice, Mitch Lyons uses stained slips to print with, but the finished artworks are on paper. Using a large china clay slab (now over 20 years old) as the plate, Lyons works into its surface with slips stained with various ceramic and paint pigments, pulling his clay monoprints off on sheets of paper which are dried, framed and displayed as 'conventional' prints

Others use plaster slabs for screenprinting, linocut prints or sponging, then work into the printed surface by drawing, trailing, and painting. The print is then removed by slip-casting (can be cut and built with), or lifting off with pre-slipped clay slabs.

KILN PRINTS

The Swedish ceramist Herman Fogelin has referred to the kiln as a sort of washing machine.[1] Similarly Grayson Perry explains, 'I try to make pots as if I were making paintings; when they fail, they do so for aesthetic rather than technical reasons. I'm not after surprises, the chance effects of the kiln. In fact, I often say that I wish there were a microwave kiln.'[2] They both value the simple function a kiln performs of transforming raw clay into vitreous objects. For others there is the pyrometric charm, the unknown imparted by wood and reduction firings. Kilns can be conceived to act as types of printing presses, imparting colour and other unique qualities. The firing process can facilitate either the transfer of colour from one body to another, or cause a print by reducing clay, carbonising matter.

1 Scott, P 2001, *Painted Clay, Graphic Arts and the Ceramic Surface*, A & C Black Publishers, London. Quoted p. 118.
2 Klein, J 2009, *Grayson Perry*, Thames and Hudson, London. Quoted p. 238.

Joanna Veevers (UK), *Honey Bee and the Hive* (detail), 2010. Semi-porcelain fired to 1200°C (2192°F). Intaglio monoprint with stained slips, 24 x 27 cm (9½ x 10½ in.). *Photo: Joanna Veevers.*

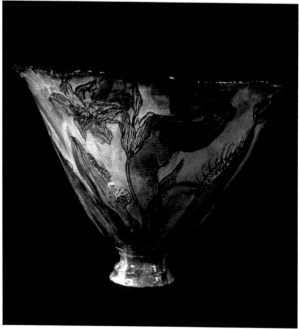

Claudia Clare (UK), *Bowl for Maria Sybilla Merian*, 1999. Intaglio plaster print, slip-cast from drop flower mould. Maria Sybylla Merian (1647–1717) was an entomologist and painter who recorded, in extraordinary detail, her travels researching insects and their food sources. 'Her work in natural history illustration, documenting the full life-cycle of an insect within a single image, made a lasting impact ... The intaglio method, which allows repetition combined with a painterly approach to image, was a parallel to Merian's own method.' Height: 32 cm (12½ in.). *Photo: Jo Bradbury.*

Mitch Lyons (USA),
Blue Shadow, 2010. Slip
monotype on paper,
56 x 33 cm (22 x 13 in.).
Photo: Carson Zullinger.

Dick Lehman has long made carbon film transfers on saggar-fired porcelain. 'Typically a saggar is partially filled with 5 inches (13 cm) of sawdust and pressed down to create a "nest". The pot is removed and fresh vegetation is positioned in the nest. Then the pot is put back in place, on its side atop the vegetation. Next more vegetation is placed onto the exposed top side of the pot. It is then covered by an additional 5 inches of sawdust. The saggar is then closed with a lid'. In the firing a *reducing* atmosphere is created inside the saggar, and the organic matter turns into activated charcoal. In the process it releases a film of carbon, which the bisqued porcelain absorbs, capturing the image of the vegetation. Although Lehman observes that the success rate is less than 20 percent, the wonder and surprise of the results that do work propel him to continue exploring the process.

Janet Williams has also worked with the firing process and organic matter to produce a variety of 'printed' images. Her work is concerned with how firing alters organic matter, carbonising it, with the residues forming the focus of some pieces.

Paul Wandless (USA), *Tools of the Trade 001*, 2007. Monoprint, linocut images. Low-temperature brown clay, underglaze and watercolor underglaze, 34¼ x 19 cm (13½ x 7½ in.). *Photo: Paul Wandless.*

Janet Williams (USA), *Condensed* (detail), 2002. Porcelain, wood, residues of *Reader's Digest Condensed*, coated with a porcelain slip and kiln-fired, 10 x 15¼ x 25¼ cm (4 x 6 x 10 in.). *Photo: Crista Cammaroto.*

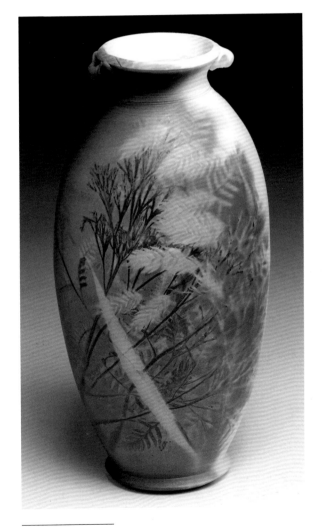

Dick Lehman (USA), *Through A Veil Dimly*, 2011. Saggar-fired porcelain. 'It was an odd and curious experience to see on my desk each day successful veggie saggar pieces, pots with delightfully delicate imagery, pots with such explicit detail that I could see the veins and tears and worm holes in many of the leaves, pots that were the ceramic counterparts to the contact prints I routinely made from my 4 x 5 negatives in the darkroom.'[3] Height: 24.5 cm (9 in.). *Photo: Dick Lehman.*

3 Lehman, Dick in *Ceramics Monthly*, March 2000, p. 35.

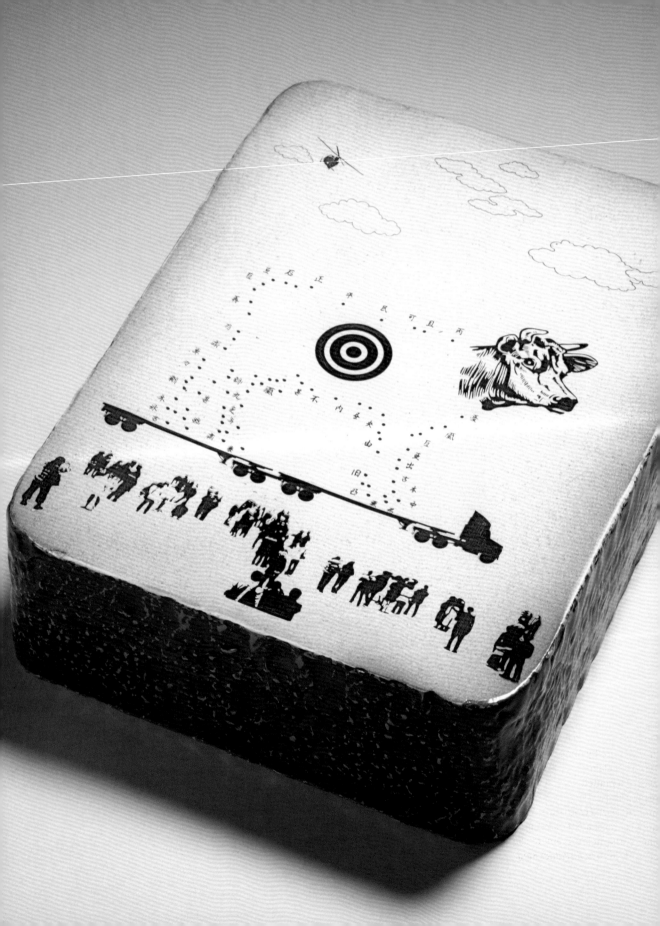

Lithographic printing

Over a number of years Patrick King (Switzerland) developed the simple toner-resist powder monoprint to create precise, deliberate graphic surfaces. In this process, glossy toner resists water-suspended powdered colour, but the absorbent paper soaks it in. Thus the negative image graphic can be printed. By contrast, rolling an oil-based ink onto a wet laser print or photocopy produces the opposite effect – colour sticks to the dry toner but not the wet paper.

A number of artists have established their own methods of printing in this way. Don Santos developed what he called the 'viscosity transfer' process. This involves wetting a photocopy or laserprint with a dilute solution of gum arabic and water, which saturates the plain paper. The watery solution does not stick to the toner; it beads or rolls off. To print from the toner, it is necessary to use ceramic colours mixed into an oil-based ink, preferably with litho varnish. Plate or stand oil will also make acceptable alternatives and Santos himself has used linseed oil in its raw state. Applied with a soft brayer or roller, the stickiness enables the ink to adhere to the non-porous toner but not the water-saturated paper. Excess can be cleaned with the same gum water solution, then blotted dry. Placing the paper face down on the leatherhard clay surface and applying light pressure using a plastic card to scrape the back will transfer the image. Using heavier-quality laser printer papers is recommended, as is handling the material quickly and carefully to avoid surface disintegration.

OPPOSITE: Scott Rench (USA), *Worship*, 2008. Slip-cast lithographic stone with underglaze and laser-print decal, 11 x 8 x 2.75 cm (4¼ x 3 x 1 in.). *Photo: Eric Young Smith.*

RIGHT: Patrick King (Switzerland), *Fragments #15: Candy Mountain* (from poems by Anne Blonstein), 1995. Porcelain-slipped raku clay with text printed using toner-resist process. The platter was broken, glazed (with the text under a transparent glaze), fired and re-assembled. Diameter: 55 cm (21½ in.). *Photo: Patrick King.*

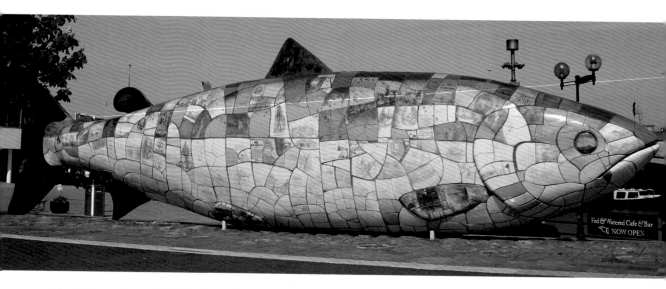

John Kindness (Ireland), *Big Fish*, Donegall Quay, Belfast, 1999. Ceramic, underglaze lithographic prints, reinforced concrete and bronze, 9.7 x 2.1 m (31¾ x 6¾ ft.). *Photo: Ewelina Wojtowicz.*

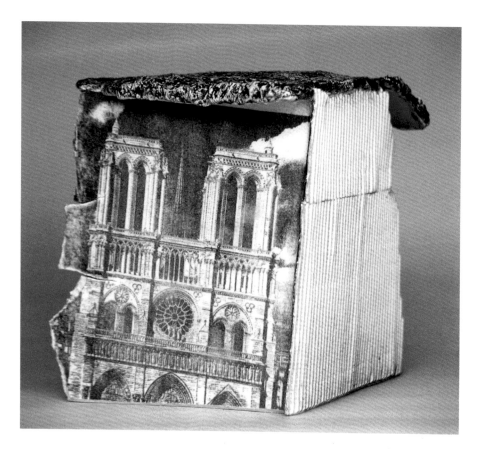

Don Santos (USA), *Gothic Shack*, 2002. Viscosity transfer from black and white photocopy, ink made from Mason stain #6371 dark teal and boiled linseed oil, lithograph element 22 x 19 cm (8½ x 7½ in.). *Photo: Don Santos.*

A number of years ago, artist John Kindness proposed the creation of a huge salmon sculpture for Donegall Quay in Belfast. Like many artists who have just been awarded a commission, he wasn't exactly sure how he would realise the work he had outlined, particularly the printing. He was concerned that the individual nature of imagery for the fish scales meant that screenprinting could prove expensive and wasteful, but at least it was a back-up. He explains:

I had seen some work decorated with photocopy toner that had been transferred onto clay with solvents, but I wanted cobalt principally, bracketed with other blues. I tried unsuccessfully to get ceramic colours into the dry toner, and then tried experiments – softening the fixed toner sufficiently to pick up the colour. I have always felt that the artist's studio is a cross between a lab and a playroom, and it was during a period of three days I had set aside just to 'play' with materials that the breakthrough came. With my assistant at the time, Maeve Connolly, we set out some tables with all the materials we had gathered to date, a copy of [the first edition of] *Ceramics and Print*, and just experimented. For some reason I wanted to see if a wet photocopy would work better in a test I was doing.

Gus Mabelson (Ireland), playground drinking fountain, Kilkenny Project School, 2005. After helping to develop glazes and colours for the *Big Fish* project, Mabelson later used John Kindness's litho process on his own school commission/project. Sequence shows wetted photocopy placed face down on inked glass, then removed and placed onto bisque tile. *Photos: Gus Mabelson.*

> Wetting a copy with a fine plant spray, I found that the toner was resisting the water and the paper was absorbing it – this was the Eureka moment when I realised that a lithographic principle could be exploited.[1]

Kindness used litho extender mixed with ceramic stains. Inking photocopies with a roller proved problematic but he experimented by rolling out a bed of ink, then laying the photocopy face down into it (as you would do with a monoprint). 'Even before we took a print, when I lifted the copy and saw that ghost image left behind in the ink bed I knew it was working. It was a great moment when we laid it down on a tile and transferred that first crude image of cranes in Belfast dock.'[2]

These simple litho systems can produce subtle photographic images, although best results are achieved by first converting from continuous tone into black and white artwork using Adobe Photoshop. Filtering software like Andromeda Screens can produce incredible subtlety and a much greater variety of effects than the standard Adobe settings.

What Santos and Kindness developed were, of course, two simple forms of lithography, which is a chemical printing process. It relies on the fact that water and grease do not mix. Very simply, in its original form, a drawing or painting is made with a greasy media on a specially prepared fine limestone. After treatment with a number of chemicals, the stone is moistened with a damp sponge and then inked up with oil-based inks. The ink only adheres to those areas covered with the greasy media. Upon contact with paper on the litho press, images and designs are transferred from the drawn and printed areas. In the past 50 years lithographic stones have been replaced with specially-prepared zinc and polyester plates. Litho stones are now only to be found in museums or printmaking studios.

Artists are now beginning to explore the use of lithographic stones to print ceramic colour onto Keraflex porcelain sheets, and onto decal paper.

Alternative industrial plates are available from appropriate suppliers. Polyester or pronto plates are the most flexible and easy to use. They are available under various trade names, and are designed to go through laser printers. Be sure to use a 'thick paper' or 'card' setting from the paper handling menu on your printer. Because polyester plates do not disintegrate on wetting, they provide a robust, effective alternative to laserprints or photocopies on paper. In addition, they can be drawn on directly with ball point pens, permanent markers or litho crayons. These plates are best inked using a roller or brayer then applied to leatherhard clay surfaces.

In the ceramics industry, litho varnish is used instead of ceramic inks for colour printing on transfer papers. After passing through the press, decal paper is dusted with the desired ceramic pigment. It sticks only to those areas printed with varnish. After drying, the decal can be overprinted from another plate, and more colour dusted on. This process is repeated until the full colour image is complete. Commercially, lithographic printing is almost exclusively used with predictable overglaze colours.

1 John Kindness, personal correspondence by email, July 2009.
2 John Kindness, personal correspondence by email, July 2009.

Kent Lien (Norway) rolling ink onto litho stone. *Photo: Paul Scott.*

Removing test print on pre-coated decal paper after printing from the stone in the litho press. *Photo: Paul Scott.*

Fired lithographic prints on earthenware test tiles with printed decal papers. *Photo: Paul Scott.*

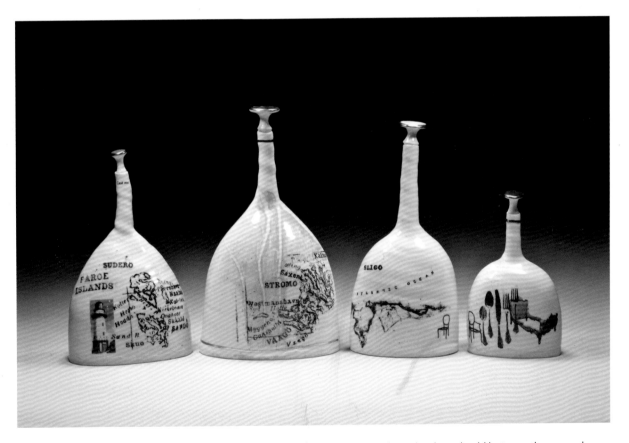

Rebecca Barfoot (USA), *North Atlantic*, 2010. Lithographic transfer prints, custom laser decals, and gold lustre on thrown and altered porcelain, height: up to 33 cm (13 in.). *Photo: Waldemar Winkler.*

5

Relief, intaglio and lithophanes

Definitions of the word 'print' typically refer to impressing – the Oxford English Dictionary defines it as an 'indentation in surface preserving the form left by pressure of some body'. Books about printmaking are usually organised into different sections that relate to relief or block printing (prints taken from the surface of a plate) and intaglio, meaning from below the surface (from the Italian *intagliare*, to engrave). Typically, prints in and on clay involve both. A variety of ceramic surfaces display impressed characteristics without pretence – the thumbprint of the thrower or hand-builder, the stamped bases of pots. Historically, more deliberative uses include textual legends displayed on ancient Sumerian clay tablets and medieval block-printed tiles. Some contemporary artists also knowingly exploit clay's ability to receive a relief surface, faithfully recording the imprint of the stamp to produce complex, detailed patterns or messages.

RIGHT: Lia Bagrationi
(Georgia), *Golden Nails*,
2003. Terracotta nails
inlaid with golden imprints
and stamped signs,
assemblage 4 x 28 x 25 cm
(1½ x 11 x 9¾ in.)., length
of each nail 25 cm (9¾ in.).
Photo: Rafael Arzumanov.

A second definition of the verb, from the same source, is the application of 'inked types, plates, blocks to paper or other material'. Within the printmaking studio, relief printing involves taking an inked impression of the face of a plate (wood block, linoleum), intaglio from under the surface (as in etchings or engravings). Printing takes place when the inked face comes into contact with the paper or ceramic surface. In the pottery industry, sponge prints and rubber stamps are the traditional relief prints, and with engraved tissue transfer prints, intaglio. Prints from plaster moulds that use the sculpted surface to create almost photographic qualities are known as lithophanes. All these kinds of prints are used in contemporary studio practice.

SPONGE PRINTING

Sponge printing has a long ceramic tradition. In the early Scottish spongeware industry, the dense root of the natural sponge was used for making stamps; today, synthetic foam produces the finest detail. The natural porosity of sponge means it can hold a

John Calver (UK), platter, 2011. Thrown with cut rim. Sponged stamps with rutile and cobalt slips, trailed iron and chrome slips, biscuit-fired clay stamps impressed in the surface (all at leatherhard stage). After biscuit-firing, seven glazes have been poured in partly overlapping layers. Fired in an oil-fuelled kiln to 1320°C (2408°F) with 10 hours of reduction, diameter: 40 cm (15½ in.). *Photo: John Calver.*

Brixton Pottery spongeware awaiting firing in the Wroclaw factory, Poland.
Photo: courtesy Brixton Pottery.

reservoir of water-based colour which enables repetition printing from one inking. A number of companies, including Bridgewater, Brixton Pottery and Nicky Mosse, are now producing spongeware on an industrial scale again. Printing usually takes place on bisque surfaces, allowing further sgraffito detail if required.

The method has also found favour with individual ceramists, who enjoy its qualities and seductive ease of use. For general use, ceramic pigment mixed with a little underglaze media, or even just water, and painted onto a tile or glass plate, will

Malene Møller-Hansen (Denmark) making a sponge stamp with a heated tool at Guldagergård, Denmark, in February 2008. Melting foam gives off fumes so this kind of work must be undertaken outdoors. *Photo: Paul Scott.*

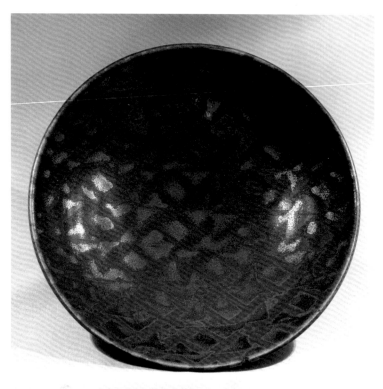

Anders Fredholm (Sweden), plate, 2011. Matt copper glaze with patterned, sponged, red-iron-oxide stamps. Fired in reduction with an electric/gas kiln to cone 10, heated by electricity and reducing the atmosphere with gas from about 1000°C (1832°F) to top temperature, diameter: 21 cm (8¼ in.). *Photo: Anders Fredholm.*

provide a perfect reservoir of ink. Sponge stamps can be created using a heated wire or sharp tool, but melting foam gives off fumes, so this must be done outdoors. An alternative method of creating sponge prints involves soaking the sponge in water, freezing it, then carving the frozen block with a scalpel.

SPONGING AND STAMPING WITH LUSTRES

Traditional sponge printing techniques and rubber stamping can be adapted for use with precious metal lustres. The resulting work is quite different in character from what is thought of as sponge-decorated ceramics. This is due in part to the surface quality these materials impart to an object. Lustres are very thin layers of precious metals applied to pre-fired (usually burnished or glazed) ceramic surfaces. Being precious metals, printing with large, conventional stamps can be an expensive business, so they tend to be used with economy and on a smaller scale.

There are ranges of coloured lustres as well as purely metallic finishes. Colours are translucent and give iridescent qualities to a surface, while metallic lustres are more opaque. They are usually supplied in liquid form ready for painting. The metallic and other colourings are revealed after firing to a range of 680–800°C (1256–1472°F).

John Wheeldon started printing with lustres after some years of making spongeware. The base glaze was overprinted with bold shapes in contrasting, brightly-coloured glazes. When he started working with lustres, he brought the technique of the sponge print to bear on very different materials with correspondingly contrasting results.

Lustres are always suspended in solvents and care should be taken when using them. Good practice involves local ventilation and the use of a solvent vapour mask.

John Wheeldon (UK), *Lidded Boxes*, 2012. Lustre printed on thrown black basalt body forms. Using an almost black-firing clay body, several layers of terra sigillata are applied to the dry surface. After bisque firing, lustre is then applied, fired and finished with a single raku firing and smoking. Wheeldon has developed a distinctive way of working with small stamps, which are often geometrical in design. The shapes are simple but by repeating them, turning them 90 or 180 degrees, he produces complex patterns with positive and negative printed shapes of differing hues and iridescence. *Photo: John Wheeldon.*

John Wheeldon's working area with lustre stamping tools. Wheeldon uses ready-mixed lustres designed for painting, but by leaving them in the open for some time, the oils and solvents evaporate, leaving a stickier, fatter lustre. This is more suitable for rolling out and printing. It is also possible to buy printing lustres in a ready condition. If they become too dry, they can be let down with lustre essence to the required consistency. Two or three lustres may be rolled together to create different colours and qualities. Stamps are made from a dense, fine, foam rubber about 7 mm (¼ in.) thick, in Wheeldon's case sourced 'from a Citroen engine gasket'. They are made by cutting the rubber with a scalpel, or for circular stamps, with a heated metal pipe (copper microbore, car aerials). Because the rubber sponge is porous, it holds a reservoir of lustre, allowing a number of repeated prints to be made before it needs to be re-inked. *Photo: John Wheeldon.*

METAL TYPE, FLEXOGRAPHY AND RUBBER STAMPS

The printing industry, in particular newspaper production, used to rely on a system of relief printing from lead type. Many potters use these to print names under pots, but others have been more adventurous with the technology.

The modern alternative to metal letterpress printing is known as flexography, which involves the use of light-sensitive polymer plates. These are made up of a flexible support sheet of polyester or thin steel with a light-sensitive polymer layer. A relief plate is made using a film negative exposed to ultraviolet light (supplied by a screenprinting studio exposure unit, sun-tan lights or sunlight). This will fix the polymer under clear parts of the film, but the unexposed surface will wash away when sprayed with warm water and scrubbed, leaving a relief surface. The plates are available in different sizes and thicknesses from appropriate suppliers.

Lenny Goldenberg (Denmark), *The Cello Suites: Erotic Misadventures, The Ear Book*, 1992. Hand-built and press-moulded ceramic book. Goldenberg uses polymer plates by rolling into leatherhard clay, impressing the typeface into the surface. After biscuit-firing, ceramic pigments are painted into the indented text. When the excess is wiped away, it reveals and accentuates the typeface, 35 x 45 cm (13¾ x 17¾ in.). *Photo: Vita Lund.*

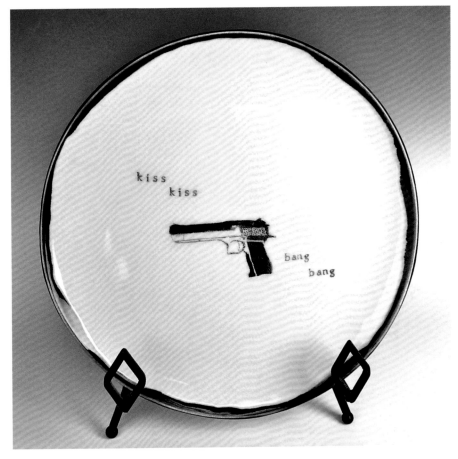

Amanda Barr (USA), *Kiss Kiss Bang Bang*, 2010. Underglaze block-printed using commercial rubber stamps and custom photopolymer stamps, diameter: 28 cm (11 in.). *Photo: Amanda Barr.*

Matthew Raw (UK), detail of fired surface, 2007. Photopolymer sheet printed into terracotta with glaze. *Photo: Matthew Raw.*

Rubber stamps and ink at a Medalta Potteries work station. Today glycerine passes as a medium for making rolling ink, but when the factory was in full production, oil-based 'printers' butter' was used. *Photo: Paul Scott.*

Rubber stamped wares awaiting glazing and firing at Medalta, Medicine Hat, in Alberta, Canada. *Photo: Paul Scott.*

Laura McKibbon (Canada), developed flexoplate. *Photo: Gio Corsi.*

It is also possible to ink up flexoplates with oil-based ceramic ink prepared with plate or stand oil for direct or indirect transfer. Highly sophisticated detailed multi-colour prints are possible if appropriate artwork is produced in Adobe Photoshop.

A more traditional relief printing technology associated with ceramics is rubber stamping. Stamps can be made to order from black and white artwork; many web-based companies can supply completed stamps from uploaded jpegs within 24 hours. It is also relatively simple to make rubber stamps by cutting soft pencil erasers with a modeling knife or scalpel.

Water-based potters' inking pads are available from some ceramic suppliers. Alternatively ceramic pigment can be mixed with a suitable sticky water-based or linseed oil medium using a palette knife, then rolled out onto a glass sheet.

More traditional print-making technology, lino and wood blocks can also be used with good rolling ink and printed directly onto clay. The possibilities include not only the conveyance of colour but also embossed surfaces. The flexibility and depth of soft or leatherhard clay allows a full impression of the whole lino block, cuts and all.

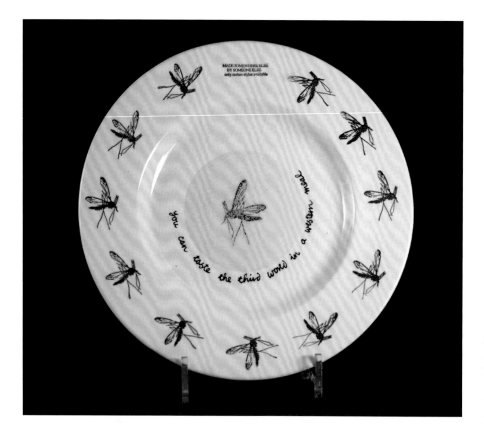

Conrad Atkinson (UK), *You Can Taste the Third World in a Western Meal*, 1996. Rubber stamps printed in underglaze and gold lustre on earthenware plate. The border fly stamp was made from a photocopied dead mayfly. 'The silence of this art is the silence of those who go unrepresented: transient migrant workers, industrial populations where employment peaks and dies, farming communities, fruit pickers and carpet workers, seekers after security who can never find it.'[1] Diameter: 26 cm (10¼ in.). *Photo: courtesy Conrad Atkinson, and Ronald Feldman Fine Art, New York.*

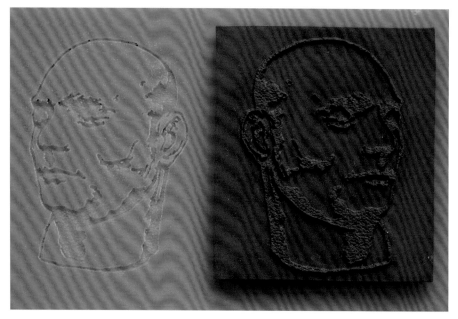

Steve Dixon (UK), *Ned Kelly* rubber stamp, cast from laser-cut acrylic sheet. *Photo: Tony Richards.*

1 Bennett, T 1996, *Transient*, Tullie House Museum and Art Gallery.

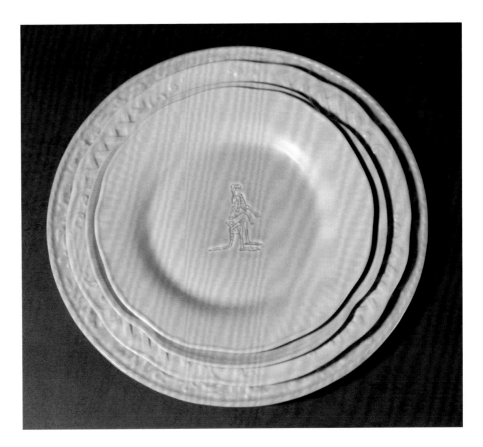

Steve Dixon (UK), *Cargo*, 2007. Stamped slip-cast kangaroo-bone-china plates. Made following a research residency project in Adelaide, *Cargo* examines the bureaucracy and legacy of colonial transportation. Antique Staffordshire plates were collected in Australia and brought back to the UK to be recast in a ceramic body containing calcined kangaroo bones (from road-kills), diameter: 14–22 cm (5½–8½ in.). *Photo: Steve Yates*.

INTAGLIO PRINTING

In ceramics, intaglio is invariably associated with the engraved copperplate patterns that gave us the rich legacy of printed blue and white tablewares left by the industrial engravers of Stoke. These migrated across the UK and thence to Scandinavia and other parts of Europe. An engraving was made by using hard, steel gravers or burins to cut lines, dots and marks in copperplates. These incised grooves held the ink, which was printed onto coated pottery tissue. Today the technology is virtually redundant, but the creative potential of printing colour from below the surface still presents fascinating possibilities for artists.

To the printmaker, intaglio means engraving, etching, aquatint and dry point. Dry point and etching are more akin to drawing than engraving. There is no particular discipline of stamping or cutting to learn and no need for particular specialist tools. Lines or marks are basically made by drawing, as you would with a pencil or pen on paper.

A dry point is made by scratching a design into a metal plate or other surface with a sharp, pointed instrument (a scribe). This raises a furrow, rather like a plough does in a field. Ink is spread over the surface of the plate, and cleaned off using a stiff canvas called scrim. The burr (small, fine pieces of material raised up on both sides of the scored line) holds the ink, not the indentation made by the scribe, which is shallow and

holds little pigment. The plate is put through an etching press in contact with damp paper, and the image is transferred. Because the burr is raised and the plate is soft, dry point prints are generally small editions, as the plate rapidly wears with the pressure from the printing press and the inking-up process.

Traditionally etchings require the biting of lines and textures into metal using a variety of mordants. A wax ground is rolled evenly onto a heated, polished plate of steel, copper or zinc, or liquid grounds in a solvent base can be applied with a brush. Once coated, artwork is drawn onto the plate through the ground using a sharp implement. A scribe, needle or nail will all make contrasting lines in an etched plate. Very little physical pressure is needed, the drawing tool gliding over the surface even more freely than a pencil on paper. Plates are etched in mild acids or mordants, depending on the type of metal used and the qualities of line required.

Tonal areas can be created by using aquatints. Traditionally, these were created by dusting the metal plate with rosin dust. Melting this over heat forms acid-resistant globules all over the surface. An alternative is to use a car enamel spray paint to finely coat the plate. By masking out areas and progressively biting the plate, a range of tones can be achieved. Traditional etching should be learned at a suitable print workshop.

A variety of non-toxic intaglio printmaking processes are now very common, and include the use of photopolymer plates used in flexography. This process is sometimes known as solar plate etching. In contrast to relief prints, a positive transparency is used to create a plate for intaglio printing.

Intaglio prints are made by inking the plate, removing the excess from the surface, and printing onto a flexible substrate. When first used on ceramic surfaces, engravings

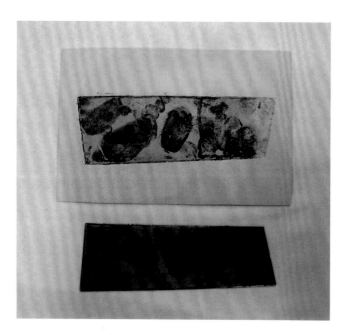

Etching test print onto Keraflex with black stain ink. *Photo: Paul Scott.*

were inked with oil then printed onto a gelatine pad before being transferred to the glazed surface. The latent oiled image is then revealed by dusting (see Chapter 2, p. 38).

Coloured intaglio ceramic inks are best made with stand/plate oil or a transparent base etching medium mixed with the appropriate pigment. Inks of different viscosities will allow over-printing, with oily inks sticking to leaner ones. Printing is best done with an etching press, onto tissue for transfers, or directly onto clay, paperclay or Keraflex porcelain tape.

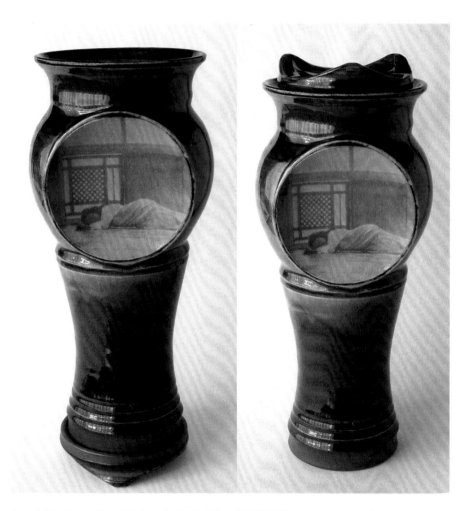

Joseph Montague (Canada), *Rounded With A Sleep #5,* 2007. 'The series was conceived as *memento mori* to be used as vases for flowers, and otherwise with cremation urns in mind. The photographic images were printed directly onto white stoneware clay, and were slumped inside a bowl to render them concave. They were then built into the thrown forms of the pots when the clay was leatherhard. The photographic areas are left unglazed. Tone separations were made and the etching plates were given a number of bites at various depths to increase the tonal range.' Stoneware with photo-etching printed directly onto damp clay, 31 x 13 cm (12 x 5 in.). *Photo: Joseph Montague.*

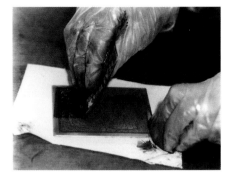 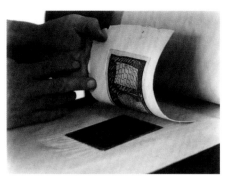

Inking an etched plate, and peeling the paperclay print off the plate after printing.
Photos: Andrew Morris.

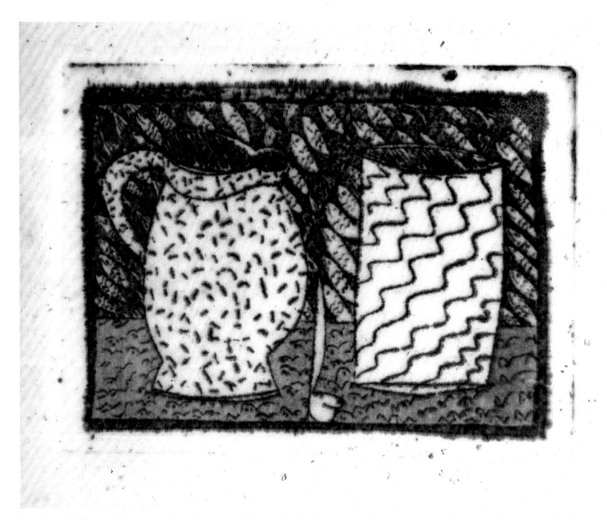

Paul Scott (UK), *Pots No. 43, Josie, Kate, Jeremy and Peter,* 1991. Etching printed onto paper porcelain, cobalt/copper ink with transparent glaze, 11 x 8 cm (4¼ x 3 in.). *Photo: Andrew Morris.*

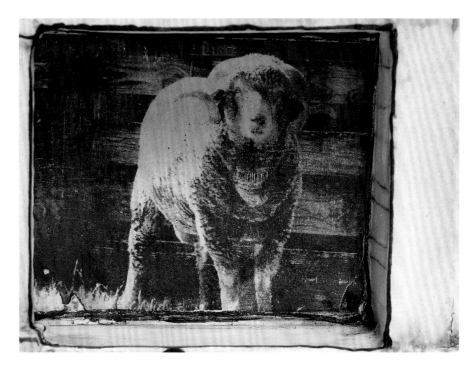

Mary Fischer (USA), *Barn With Sheep*, 2010. Ceramic sculpture with layered slip and transferred solar plate intaglio print, 25 x 28 x 13 cm (9¾ x 11 x 5 in.). *Photo: Holly Williams.*

RELIEF AND LITHOPHANES

Reference has already been made to clay's ability to record both the relief and intaglio of a plate. This is no more obviously demonstrated than in the production of tiles and tablewares from plaster moulds. Generally these involve little colour transfer; instead, the perceived graphic relies on the relief of the print, emphasised by tinted glaze. The thickness of the vitreous colour conveys light and dark in a pattern or image and is referred to as *émaux ombrants* (French, 'enamelled shadows'). The process was developed in France at the Rubelles factory by Baron A. du Tremblay, who patented the process in 1842.

Glazed reliefs developed from lithophanes (from the Greek *litho*, stone, and *phanes*, appearance), which were also patented in France in 1827. These extraordinary reliefs are puzzling non-entities when viewed with just surface light, but when illuminated from the rear give a magical photographic quality to the formed image or pattern. In contrast to these glazed forms, lithophanes rely on the thinness of porcelain for their extraordinary effect. They are negatives of *émaux ombrants*, the thinnest clay being the lightest surface when illuminated from the rear.

Lithophanes are made by slip-casting from relief moulds. Traditionally these are made by casting hand-carved sheets of wax, but today, digital cutting allows printed photographic works. Because of the translucency of porcelain, lithophanes can also be enhanced by additional painted or printed colour.

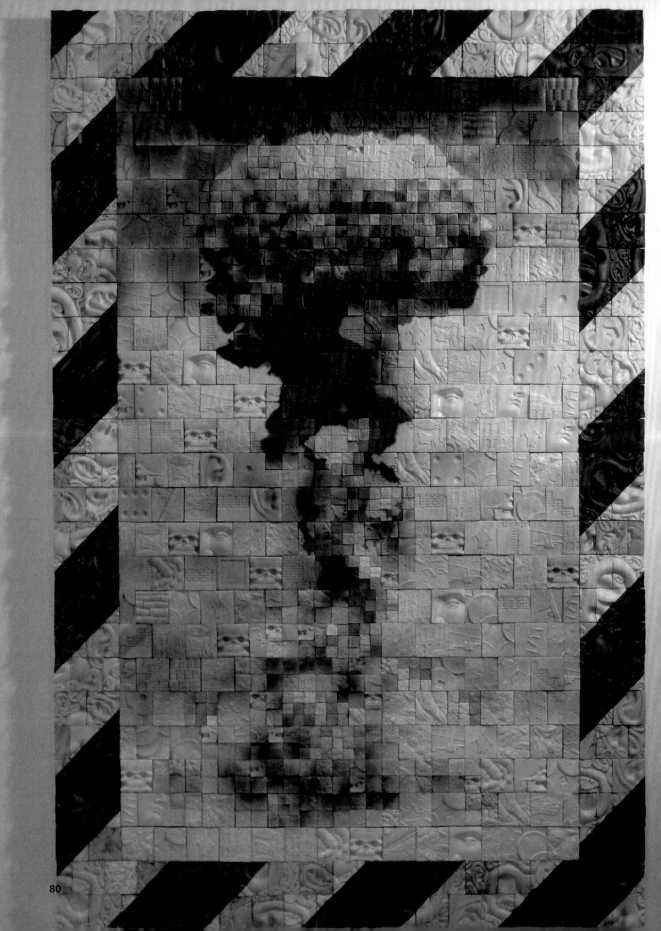

Hannah Blackwell (USA) carving a wax sheet to create artwork for a lithophane. Blackwell undertook extensive research into lithophanes at the International Ceramics Studios in Kecskemét, Hungary, in 2009. 'Having cast the wax on glass, I use a light box to render the image. Upon completion, the work will go through a process of mould to casting, silicone to plaster, plaster to plaster, getting back to a positive image and ready to cast in porcelain. After casting there will be a certain amount of clean up. I won't count any of them as certain until they come out of the kiln. There are so many variables involved in firing lithophanes – cracking, warping, iron spotting, you name it, it could and can go wrong. I have been averaging about 40% success. I have no desire to make 100 of each image. I want each one to be unique.'[2] *Photo: George Timock.*

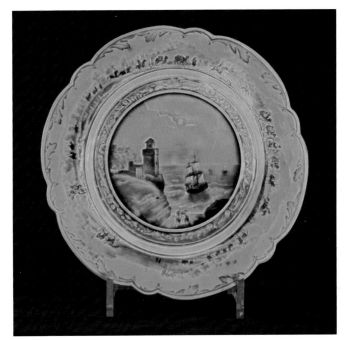

Earthenware *émaux ombrants* plate, probably French c. 1850 from Rubelles. Author's collection, diameter: 20 cm (7¾ in.). *Photo: Paul Scott.*

Richard Notkin (USA), *The Last Syllable of Recorded Time,* 2010. Press-moulded white earthenware tiles, glaze, watercolor and pastel, 197 x 131 x 6 cm (77½ x 51½ x 2½ in.). *Photo: R. Notkin.*

2 From an interview with Hannah Blackwell by Dr Margaret Carney, Curator, Blair Museum of Lithophanes, Toledo, Ohio, USA, *Hands Illuminating Porcelain: The Lithophanes of Hannah Blackwell,* Spring 2011.

Jan Pettersson (Norway), *Tile*, 2004. Research at the University of the West of England investigated George Cartlidge's Sherwin and Cotton tiles.[3] In a contemporary re-working, the hand sculpting of the original process was replaced by digitally translating tones of an image into 256 different layers. The co-ordinates were milled using a CNC milling machine into plaster slabs, which were then slip-cast, 21.5 x 19 cm (8½ x 7½ in.). *Photo: courtesy of the Fine Print Department, University of the West of England.*

3 Thirlwel, P (ed.) 2004, *Altered Images*, Making Space Publishers. See also Pettersson, J 2007, *Photogravure, An Archaeological Research*, KHiB, Norway.

Hannah Blackwell (USA),
Woman with Bike, 2009. Cut-out lithophane lit from the back in Herend porcelain,
26 x 20 cm (10¼ x 7¾ in.).
Photo: Hannah Blackwell.

Ewelina Wojtowicz
(Poland), *Being Between*,
2010. Porcelain, lithophane
(mould cast from etched
steel plate) with water-
based screenprint. Made
whilst Wojtowicz was
studying at the University
of Ulster in Belfast,
24 x 24 cm (9½ x 9½ in.).
Photo: Ewelina Wojtowicz.

6

Stencils and screenprinting

STENCILS

LEFT: Trine Hovden (Norway), *Hovden 1*, 2010. Earthenware, direct screenprint with engobes, 25 x 30 cm (9¾ x 11¾ in.). *Photo: Katrine Køster Holst.*

Historically, stencilling was a precursor to screenprinting, but the simplicity of the process continues to make it ideally suited for ceramic materials. In essence, stencilling involves masking areas with a thin sheet of (usually) flexible material, such as paper, plastic or metal, with designs cut in the mask. Alternative processes involve painted resists such as gum, latex, PVA and shellac. Pigment is applied by sponge, brush or spray through cut-out holes or on unpainted areas. Stencils cut from a robust material can be reused to reproduce the same artwork.

Lead stencil originally used to decorate tablewares. From the Medalta Potteries, Medicine Hat, Canada. *Photo: courtesy of Aaron Nelson, The Shaw Centre, Medicine Hat.*

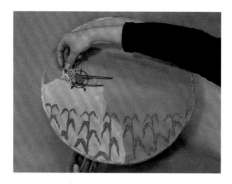 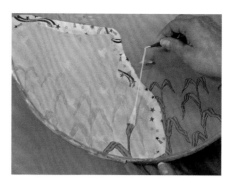

LEFT: Kip O'Krongly (USA) making *Corn Duster* plate, here removing the aeroplane stencil.
RIGHT: O'Krongly removing latex mask from sgraffito drawn corn. Note stencil details made from the plastic tablecloth previously applied – birds, edge of yellow (crop dusting area), and aeroplane above yellow painted area.
Photos: Kip O'Krongly.

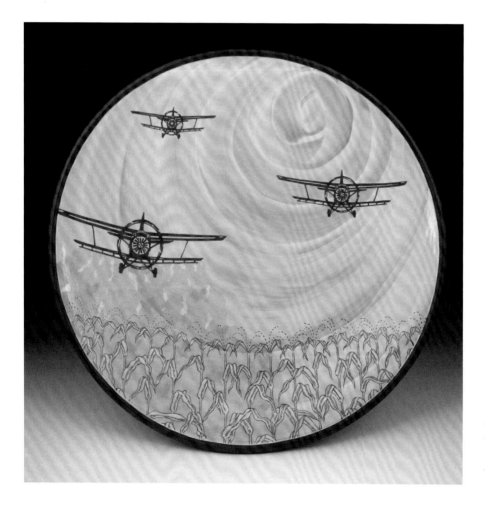

Kip O'Krongly (USA), *Corn Duster*, 2011. Hand-built earthenware with hand-cut stencils, slip, sgraffito, underglaze and *terra sigillata*, diameter 43 cm (17 in.). *Photo: Kip O'Krongly.*

SCREENPRINTING

Screenprinting or serigraphy is a technical development of stencilling. In this case, the masks are held in or on a substrate of fine mesh. Silk, polyester, nylon or steel fabrics are stretched on frames of wood or metal. Designs are put on screens in substances that effectively block the mesh. These are transferred to paper, clay or other surfaces when the screen is placed over the substrate, and a squeegee pulled across the inside of the frame forcing ink through the open mesh. Where the screen is blocked, no colour appears.

In practical terms, screens for direct printing onto clay can be made cheaply in the studio from basic materials, including mitred slate battening, screws, mesh and a staple gun. If you want precise, controlled, colour-registered multi-prints, or fine-quality detail, then more expensive, professionally-produced aluminium frames are required. These are available from screenprint suppliers. For any advanced work it is advisable to undertake a proper serigraphy course.

Glancing at a supplier's mesh listings can be extremely confusing, but for most common studio, print and ceramic use, monofilament polyester is the best material to use. It is tough, dimensionally stable, and designed specifically for the job it does. Printing fabrics are usually available in three different colours, white, yellow and orange. Mesh sizes are measured in threads per centimetre (Europe) or inch (North America). Numbers on the corners or edges of screen fabrics indicate this count,

Anima Roos (Belgium), porcelain bowl, 2011. Thrown porcelain. Outside pattern made by painting with acrylic medium; once dry, non-covered is wiped. Inside, oil-based sceenprinted decal transfers, 12 x 12 cm (4¾ x 4¾ in.). *Photo: Anima Roos.*

usually juxtaposed with a second number that refers to the thread diameter. Thread diameter and mesh count together determine the mesh opening – the open spacing between woven fibres. Mesh openings dictate the maximum particle size you can use in an ink; it also affects printed detail. For achieving the best ink passage through any mesh count, the maximum particle size should be smaller than a third of the size of the mesh opening. Too fine a screen will affect colour, and printing will soon produce a remainder ink that is too coarse to pass through the mesh. Too coarse a screen will produce imprecise prints and colour that is too dense and thick. In reality few ceramic materials are labelled with pigment size, so simple print testing may well be necessary.

Bold, large shapes with little detail will probably be best produced on a screen of 40 to 80 threads per centimetre. Printing with slips and glazes also requires a more open screen to allow pigments to pass though the fabric. Underglaze colours can usually be

Vicky Shaw (UK), *Untitled*, 2009. Porcelain paperclay mix, direct screenprinted underglaze colours and stoneware glazes in water-based medium, monoprinted coloured slip from newsprint and underglaze colours (pottery tissue), with multiple firings to 1250°C (2282°F). Shaw uses blank silkscreens, adapting them with masking tape, paper and simple stencils to screen glazes and ceramic pigments for abstracted prints. Using water-based media, she exploits the screen's tendency to block, sometimes forcing colour through the screen with palette knives and drawing onto the printed surface before firing. Prints are made on thin sheets of porcelain and are multi-fired. The unique qualities of these objects are dependent on the synthesis of printing with the interaction of ceramic pigments, slips, glazes and the firing process, 21 x 26 cm (8¼ x 10¼ in.). *Photo: Steven Allen.*

used with meshes up to 120 threads per centimetre, and specially prepared overglaze colours through 150-mesh screens. If you need very fine detail, use overglazes, or professionally mixed ink. If you do make your own, specify when ordering colours that they are for screenprinting. Give the mesh size and ensure that colours are well mixed with media.

The simplest screenprint is made by squeegeeing ink through a blank screen. This will produce an area of solid colour. By masking areas with tape or paper, un-inked areas will be created.

More elaborate prints can be created by using a blocking-out medium and painting this directly onto the screen. Unless the desired effect is that the image degrades on printing, the blocking-out medium should not be dissolvable by the print medium, i.e. oil-based inks will require a water-based blocking medium.

Almost any design can be transferred to a silkscreen by using photosensitive screen emulsions or films. These are applied to the screen before exposure, through a positive to ultraviolet light. Films can be applied from sheets of photo-stencil material, or squeezed on with photosensitive emulsion. Oxides, underglazes, slip and glazes require

Mark Heidenreich (Australia), *Untitled*, 1987. Earthenware coiled form on a potter's wheel, like the early Greek Attic pots that were its inspiration. 'I was exploring as I went, screenprinting ceramic colourants directly onto the raw pieces. The simplest images were painted in negative onto the screens. Then I began to use a light-sensitive emulsion blacked out with transparent photocopies. The large images were photos I took from around my Sydney neighbourhood, made up as screens and squeegeed directly onto the pots (accompanied with much cursing because of the difficulties of screening on such an irregular surface).' Height: 100 cm (39¼ in.). *Photo: courtesy of Mark Heidenreich.*

a relatively heavy deposition on printing so emulsion should be applied by using at least three passes through the coating trough. There are many different brands of photosensitive emulsions, some available in art shops, others from screenprint suppliers. Sericol lists eight different Dirasol Diazo Photopolymer Emulsions, and Ulano nine similar products, so for best results buy from a specialist supplier, ensuring you explain the purpose of your serigraphy (using particulate ceramic pigments) and system (oil- or water-based). Handle films and emulsions in subdued or yellow light and store in a cool dry place.

All photopolymer emulsions require appropriate UV exposure. The source can be as simple as sunshine or daylight. In the studio, metal halide, mercury vapour, carbon arc lamps or sun-tan units can be used. The positive used to transfer artwork can be as simple as a found, flat object that is opaque or contains areas of opacity. It can be hand-drawn on acetate, tracing or drafting film. Computer artwork generated in Adobe Photoshop or Illustrator should be printed by inkjet or laser print on appropriate transparency or lasermat film. It is even possible to use artwork on ordinary photocopy or laser paper; painting with cooking oil renders the substrate translucent. Whatever the positive, it must be placed between the light source and the coated screen.

Exposure time is affected by the type of light source, film/emulsion type, and the density of the image on the positive. After exposure, the screen is developed in a spray of lukewarm water, which washes out the unexposed film. After printing, screens are easily reclaimed for re-use by using a proprietary screen cleaner.

Because a silkscreen only prints in colour or no colour, it cannot reproduce tones or greyscale, so these should be processed before use. A low tech approach to photographic images is to reduce them to simple black and white by photocopying the original, then photocopying the photocopy until all the greys have gone. Adobe Illustrator or Photoshop allows much more sophisticated manipulation of images. Traditionally, screenprinting photographs was done by creating halftone positives. The simplest way to understand halftones is by close examination of a newspaper photograph. Large dots are close together and create the illusion of a dark area, smaller dots are widely spaced and create the illusion of lighter tonal areas. In the same way, a halftone positive breaks up all tonal areas of an original and translates them into a black dot system. Photoshop can do this but allows sophisticated prior image manipulation, such as alteration of brightness, contrast, colour balance, and colour levels. In addition, filters like Andromeda Series 3 Screens, Etchtone or Cutline (Photoshop plug-ins) allow an alternative method of producing positive images, by creating randomly-generated dot matrices. Instead of reducing and enlarging dot sizes to create areas of light and dark as in a halftone, the programme randomly (or in a patterned way) scatters smaller or larger dots corresponding to the tonal areas of the image processed.

Screenprinting can be as basic as using paper stencils or masking tape to block out relatively large or crude areas, or as sophisticated as having multiple screens printing four-colour prints from computer-originated images.

Screens should always be larger than the images to be printed; allow at least an extra 10 cm (4 in.) border around the artwork, ensuring space for ink, squeegeed colour, and for the screen to stretch as the squeegee is used. Ideally there should

Maria Geszler (Hungary) printing directly with a telephone card. *Photo: courtesy of Maria Geszler.*

Caroline Möller (Sweden) with her home-made UV light exposure unit. The top of the trolley doubles as part of a glaze spray booth. Many artists are inventive in adapting their studios and equipment for multiple uses. *Photo: Paul Scott.*

always be a gap between the screen and printing surface; this is called the snap. Purpose-made screenprint tables have mechanisms to enable this. Snap can also be created by taping strips of card to the underside of the frame. Low opacity on printing and poor registration are often caused by insufficient snap, and over-heavy deposits by too great a gap. Squeegee hardness/softness, printing action and angle all affect print quality.

DIRECT SERIGRAPHY

Those who print directly on clay often break all sort of serigraphic rules. They often work without a snap, preferring inexact and blurred qualities, which are later enhanced by different kinds of firing and over-glazing. Maria Geszler sometimes famously works with mesh removed from the frame, directly on clay, 'working with my finger and telephone cards. This way it is possible to work very sensitively and put many colours over the surface.'

Some artists print with slips, engobes, ready-made water-based underglaze colours or inks mixed with glycerine, wallpaper paste, water and CMC (cellulose gum). Direct prints on clay are, however, made easiest by using an acrylic screenprinting medium, available from art stores and suppliers. It produces an agreeable, easy-to-use ink.

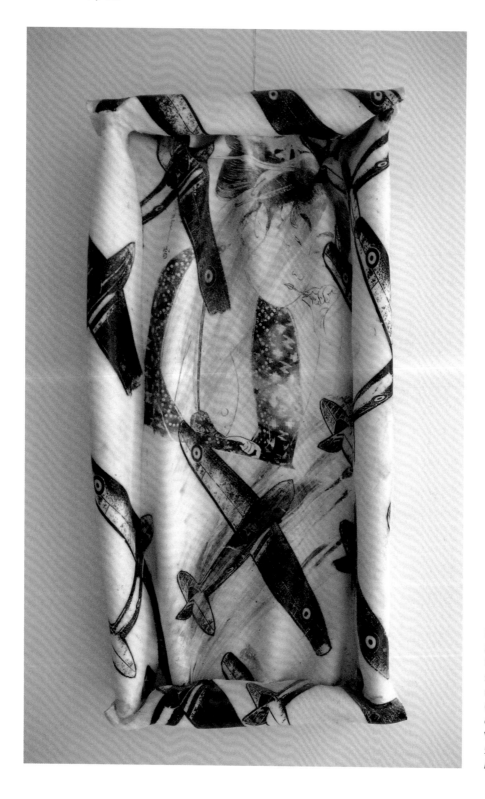

Maria Geszler (Hungary), *Bombing Geisha*, 2000. Porcelain wall-plate with screenprint, fired in a gas reduction kiln to 1360°C (2480°F). In the collection of the Keramikmuseum Westerwald, Germany, 61 x 50 x 10 cm (24 x 19½ x 4 in.). *Photo: Maria Geszler.*

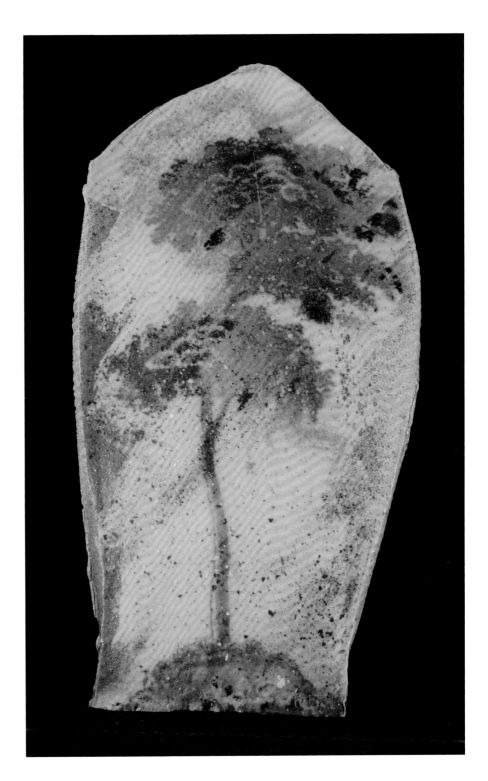

Paul Scott (UK), *Spode Tree*, 2010/2011. Slab-built form with porcelain slip, direct screenprint, wood/soda-fired at Guldagergård, Denmark. Splashed gold lustre. Ink colour density should generally be less intense for wood-, salt- and soda-fired works to retain detail and graphic fidelity, height: 33 cm (13 in.). *Photo: Paul Scott.*

Marianne Requena (France), *Menace*, 2010.
Screenprint on clay and various stamps.
The clay is applied to each side of a
woven mesh, 40 x 100 cm (15¾ x 39¾ in.).
Photo: Marianne Requena.

Scott Rench (USA),
Interactive Ceramics, 2006.
Direct print with Amaco
underglazes onto ceramic
forms, each block 9 x 9 x
9 cm (3½ x 3½ x 3½ in.).
Photo: Eric Smith.

Megumi Naitoh (USA), *Real Life/Virtual Life, July 14th*, 2009. Wall relief with three vantage points. Direct printing can also be done with relatively sophisticated four-colour CMYK process. Hand-screenprinted directly on wet earthenware slab with underglazes, 78 x 50 x 5 cm (30¾ x 19½ x 2 in.). *Photo: Megumi Naitoh.*

SERIGRAPHIC TRANSFERS

Printing directly onto clay can be problematic and imprecise. Some artists prefer to print onto more absorbent surfaces first before transferring images to clay. For these technologies to work, the artwork must be printed onto an absorbent surface in a medium that remains water-soluble. Transfers are made from fixed or flexible substrates.

Slips, engobes and ready-made underglazes, widely available in North America, can be screenprinted onto flat plaster bats. Poured casting slip, or suitably-wetted, rolled clay tiles will lift the prints off the plaster surface. The resulting artwork can then be used for slab-building, as in the case of Les Lawrence's work, or as tiles.

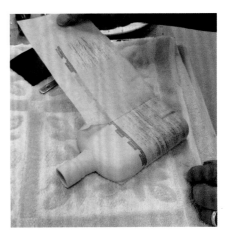

Applying a water-based screenprinted tissue transfer to dry ware in Bat Trang, Vietnam. The surface of the plate is wetted using a soft brush before the paper transfer is applied face down. The back of the print is rubbed using a damp brush. Removing the tissue reveals the transferred print. *Photo: Paul Scott.*

Removing the acrylic transfer print from the wet clay form. *Photo: Vipoo Srivilasa.*

Paper transfers work in the same way but provide a more flexible substrate so the print can be conveyed to curved or rounded surfaces. Slips and ready-mixed underglazes must be used immediately as, on drying, the flexibility of the paper causes cracking or flaking. Acrylic screenprint medium, on the other hand, sticks to the paper and is the most flexible as long as the correct type is used. Ready-prepared acrylic inks used in the printmaking studio usually dry waterproof. The key for ceramic paper transfers is to use the screenprint medium sometimes also sold as extender. This material stays water-soluble even on drying, although when cured after a few weeks it will take longer to reconstitute. Using this as a medium enables the printing of water-based paper prints that can be stored almost indefinitely.

For dry and biscuit surfaces, alternative media include linseed-based plate and stand oils, favoured by many in Scandinavia. This is slightly less precise in its transfer of detail as the ink has to be wet or sticky to make an effective transfer. Some distortion is inevitable as pressure fixes the ink to the ceramic surface.

Åsa Jacobson (Sweden), *Cow Plate*, 2007. Serigraphic tissue transfer on earthenware plate, diameter: 33 cm (13 in.). *Photo: Åsa Jacobson.*

Tuula Lehtinen (Finland), *Ainos and Lauris Porcelain Dance* (detail), 2011. Silkscreen-printed porcelain. Printed on a thin paper with cobalt carbonate in a water-soluble printing media. 'To transfer the print I first wet the porcelain surface with a light mixture of gum arabic (this is to make the ink adhere better). I wet the back side of the print with a spray bottle and then use a sponge to press it tightly on the surface. The ink mixes a little with the glazing and gives a painterly effect … The forms are slip-cast from moulds of my father's and mother's real shoes. Inside some, you can see images of my parents when they were very young.' *Photo: Timo Nieminen*.

Laura McKibbon (Canada), *What are you reading?*, 2007. Hand-built earthenware, silkscreen underglaze tissue transfers. Graphics derived from punctuation from the first page of John Ralston Saul's *The Unconscious Civilization*, 35 x 18 x 2.5 cm (13¾ x 7 x 1 in.). *Photo: Laura McKibbon*.

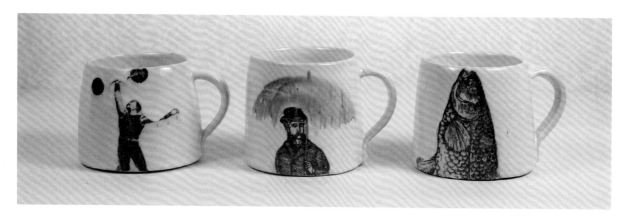

May Luk (USA), *Mugs*, 2011. Wheel-thrown mugs with cobalt transfer prints. Water-based underglaze silkscreen print on tissue, transferred to greenware, height: 10 cm (4 in.). *Photo: Nguyen Le.*

Charlie Cummings (USA), *Untitled*, from *Daytrip* installation, 2011. Screenprinted onto plaster then monoprinted. 'I start with photographs I have taken on research trips to the Springs in north-central Florida. I adjust the colour in Photoshop and separate the image into four halftone films: cyan, magenta, yellow and black. The halftone films are used to expose four silkscreens. I silkscreen underglaze colors that are analogous to cyan, magenta, yellow and black onto a plaster slab in the reverse order that I want them to appear on the final print. Porcelain slip is poured on the image. When the slip has solidified enough to handle, the slab is removed from the plaster, retaining the underglaze image in the surface of the slab.' 38 x 50 x 2.5 cm (5 x 11½ x 2 in.). *Photo: Charlie Cummings.*

Ane-Katrine von Bülow's tissue prints, screenprinted and ready to use. Von Bülow uses an ink made with stand and linseed oils. This produces an open, sticky print that remains workable for some time. *Photo: Paul Scott.*

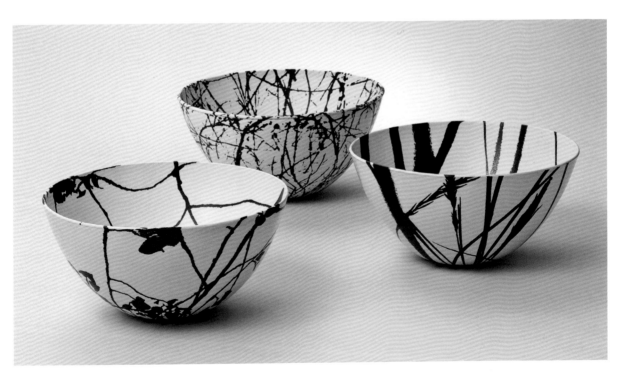

Ane-Katrine von Bülow (Denmark), bowls, 2009. Porcelain forms with photographic images from nature silkscreen-printed onto tissue and transferred to porcelain slip-cast forms, matt or shiny glaze, 1280°C (2336°F). Ane-Katrine von Bülow makes tissue stencils especially to fit the forms, 'like a dress made to fit a woman', 24 x 48 cm (9½ x 18¾ in.). *Photo: Ole Akhøj.*

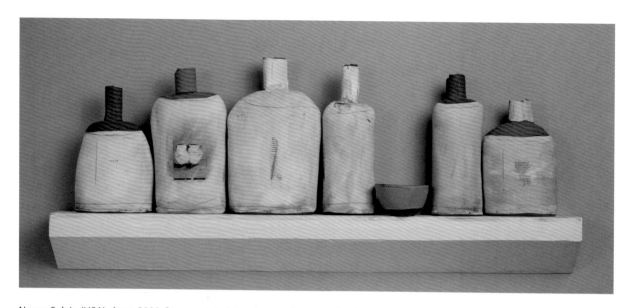

Nancy Selvin (USA), *Anza*, 2009. Screenprinted drawings and text, underglazes and underglaze pencil on earthenware forms, 61 x 122 x 12 cm (24 x 48 x 4¾ in.). *Photo: Kim Harrington.*

Stephen Dixon (UK), *The Jewel 1*, 2010. Press-moulded earthenware plate, underglaze slip painting, impressed stamps and sprigs, onglaze and inglaze water-based screenprinted decals, painted gold lustre. From a series of plates which examine the contested shared histories of India and the UK through a layering of printed imagery, exhibited as Embedded Narratives at the Loft, Mumbai in 2010, diameter: 31 cm (12 in.). *Photo: Tony Richards.*

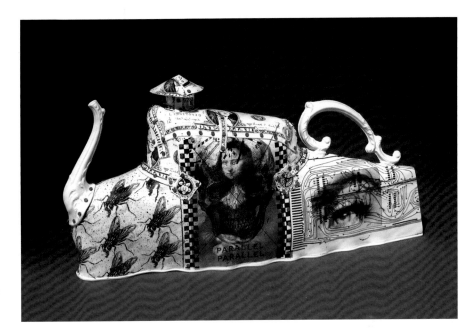

Les Lawrence (USA), *New Visions Vessel A30402*, 2002. Water-based silkscreen monoprint from plaster on porcelain with stainless steel, 38 x 10 x 8 cm (15 x 4 x 3 in.). *Photo: John Dixon.*

OIL AND WATER-BASED DECALS

The conventional methodology for using silkscreen transfers involves the creation of decals. These are traditionally made with oil-based inks printed onto gum-coated transfer paper, subsequently coated with covercoat lacquer (this is usually printed through a blank screen). As both media are oil-based, you will need good exhaust ventilation when using them. In addition, solvent washes used to clean screens make their use unpleasant and potentially dangerous; appropriate vapour masks are strongly advised. Whilst still in common use in industry, this methodology has gradually been replaced in most studios with water-based alternatives, using pre-coated decal paper and acrylic printing media that are waterproof on drying. Others simply pay to have their artwork printed for them. Until recently, most decals made to order will have been made using serigraphy, but the development of digital printing has made four-colour photographic transfers affordable and readily accessible.

Ole Lislerud (Norway), *Financial Times 1*, 2007. From the exhibition *Metaphorical Signs* at the Today Art Museum, Beijing. Inglaze decals and overglaze painting. Images from the *Financial Times* newspaper made into decals at the Porsgrund Porcelain factory (Norway), produced by Astrid Høydalen. Tiles made and multi-fired at the studio of Mr Liu, Laujatan, Jingdezhen, China, 2 x 1 m (6 ft 7 in. x 3 ft 3 in.). *Photo: Marian Heyerdahl.*

Poul Jensen (Denmark/Norway), *Growth* (detail), 2011. Relief tiles printed from plaster and sceenprinted glazed porcelain tiles. Oslo National Academy of the Arts Norway, 0.85 x 14.5 m (2¾ x 47½ ft). *Photo: Morten Løberg.*

Jeanne Opgenhaffen (Belgium), *Cubes*, 2009. Screenprinted decals from Opgenhaffen's drawings on porcelain forms, 5 x 5 x 5 cm (2 x 2 x 2 in.). *Photo: S. Van Hul.*

7

Decals, photocopies and digital prints

OPPOSITE: Grayson Perry (UK), *The Names of Flowers*, 1994. Graphic surface includes overglaze decals and stenciling. Perry's ceramic surfaces have always comprised complex layers of slip, colour, lustre and glaze. His graphic methodologies include drawing, painting, stencils and decals; more recent pieces have made extensive use of digital decals, 42 x 28 cm (16.5 x 11 in.). *Photo: courtesy of the Artist and Victoria Miro Gallery.*

OPEN STOCK DECALS

Open stock (usually overglaze) decal prints are available from ceramic printers. Generally purchased in large quantities by industrial producers of tiles, domestic ware or gift-ware, there is a wide variety of imagery to choose from, some of it quite bizarre. Sheets of pre-printed colour are also available from some suppliers. All these sources have been plundered and widely used by artists since the pioneering dabbling of Howard Kottler many years ago.

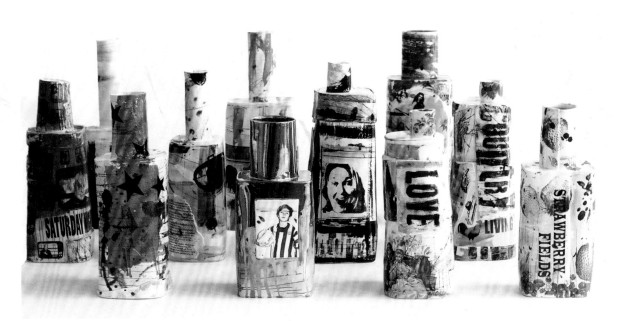

Elisabeth Laursen (Denmark), *Grauballe Souvenirs*, 2011. Objects created using a variety of print processes, monoprinted from plaster, impressed type, open stock and laser decals, inglaze and overglaze prints on high-fired white earthenware, height: 40–47 cm (15¾–18½ in.). *Photo: Jens Riis.*

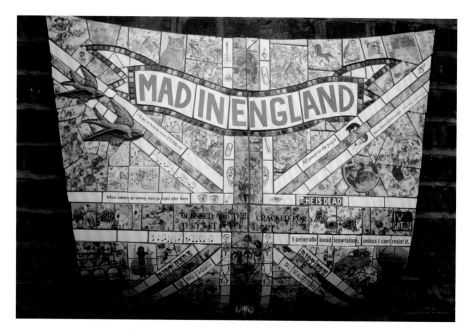

Carrie Reichart (UK), *Mad in England*, private commission 2011. Mosaic with printed tiles using digital transfers, hand screened, vintage transfers, found objects and slip-cast ceramics on mini bonnet. *Photo: Camilla Grace Boler.*

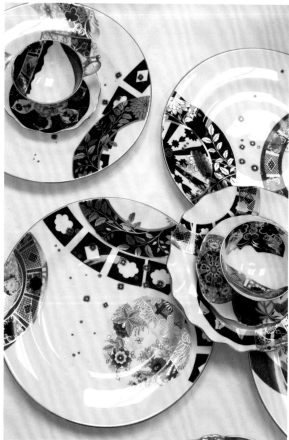

Peter Ting (UK), *In Quarantine*, 2008. Overglaze decal collages on bone china tableware. The complex nature of bone china production coupled with the constant striving for perfection within Royal Crown Derby results in the inevitable by-product of a small mount of flawed litho sheets. Peter Ting turned the unflawed areas into high-end desirable objects. *Photo: Jan Baldwin.*

Lippa Dalén (Norway/ Sweden), cup, 2011. Overglaze open stock decals, collaged on a thrown earthenware cup with slip and clear glaze. Dalén is well known for her work, with its sensuous combination of thrown, slip-coated terracotta tablewares and floral prints. Over the years she has collected the text from sheets of open-stock decals and has now put these to use, height: 9.5 cm (3¾ in.). *Photo: Lippa Dalén.*

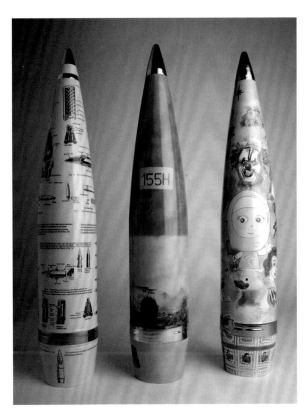

Peter Lewis (UK), *H155*, 2010. Slip-cast from a mould of a 155 Howitzer shell. Semi-porcelain with inglaze and overglaze decals, painted enamel and lustres, height: 85 cm (33½ in.). *Photo: Adrian Greenhalgh.*

COLOUR LASER DECALS

The use of pre-printed, found tableware has become an area of much exploration in recent times, and artists' palettes have been richly enhanced by the development of digital decals. These are produced in colour laser printers loaded with specially manufactured ceramic toner. The machines themselves are adapted conventional laser printers, and have to be operated with attention to specific print settings, with a thin decal paper fed through the bypass tray. After printing, covercoat lacquer is usually applied from special pre-coated sheets through a laminating machine. Most artists order their custom-made decals through online print suppliers.

Garth Johnson (USA), *Moon Magic*, 2006. Assemblage of 42 found, blank porcelain and collector plates with laser decals, fired and unfired digital prints, overglaze and lustre, 126 x 146 cm (49½ x 57½ in.). *Photo: Garth Johnson.*

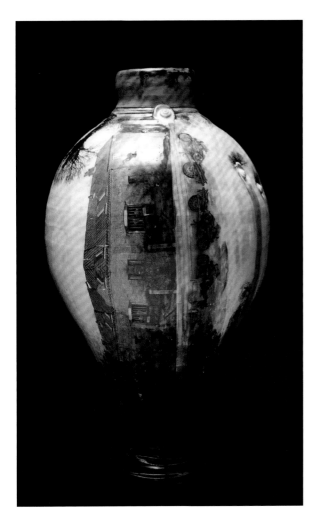

Lone Borgen (Denmark) and Stephen Parry (UK), *Between Norfolk and Jutland*, 2011. Digital prints on earthenware form, height: 59 cm (23¼ in.). *Photo: Jens Peter Engedal.*

Andy Shaw (UK), *Automatic Freedom Writer*, 2004. Impressed text and digital decals on glazed ceramic form with lustre, 42 x 16 cm (16½ x 6¼ in.). *Photo: Andy Shaw.*

Laser decals provide full-colour graphic fidelity without the need for elaborate four-colour screen or lithographic processes. It is even possible to print directly onto Keraflex sheets. Laser prints also offer the opportunity to produce an endless array of different images without the need for complex multi-colour screen set-up procedures.

The means to produce sophisticated multicolour laser-prints in the studio may be out of reach for most artists because of the cost of printers, but it is quite possible to make sepia decals from conventional home office mono-lasers and photocopiers.

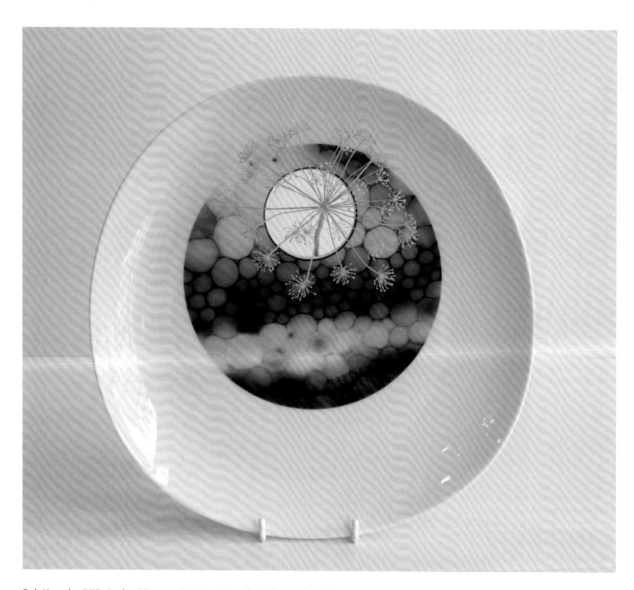

Rob Kesseler (UK), *Jardim Microscopica*, 2011. Porcelain plate with cellular plant print and fresh plant material, glass vessel. One of a series of works created during a Fellowship with the Gulbenkian Science Institute in Portugal. Working with molecular biologists, micro-fine sections of wildflower stems were photographed on high-resolution microscopes, revealing complex structures and colourful patterns. In a celebration of the historical tradition of botanically-inspired decoration on tableware, the cellular images were used to develop a series of enamel prints produced in collaboration with the Portuguese manufacturer Vista Alegre Atlantis. The prints were applied to a collection of plates from the Karma range from VAA, selected for its irregular profile, which reflected the soft cellular shapes. A total of 50 plates were laid out in a loose cellular structure echoed by the image of a complete plant section printed onto the canvas on which they sat. Small glass vessels emerge from holes in the large platters, receptacles for fresh flower specimens, markers that remind us of our ever-evolving relationship with nature. Diameter: 28 cm (11 in.). *Photo: Rob Kesseler.*

Monica Larsson (Sweden), *Kommer hem/Coming home*, 2008. Digital print decals fired on tiles, 20 x 20 cm (7¾ x 7¾ in.) and 10 x 20 cm (4 x 7¾ in.). Mounted at eye level in an apartment building in Stockholm. 'The thought is that you walk through the forest and are coming home to your palace/apartment.' Total length: 5.4 m (17¾ ft.), height: 30 cm (11¾ in.). *Photo: Monica Larsson.*

Magdalena Gerber (Switzerland), *Tellerstories*, 2002–9. Porcelain, digital ceramic print, gold. Laser-print decals from video stills on porcelain fired to 1000°C (1832°F), with gold lustre. 'Around a table we all tell stories; every plate has a different video-still, every plate tells another story.' For a number of years, Gerber has led research into ceramic digital printing at CERCCO, the Centre for Experimentation and Realisation in Contemporary Ceramics of Haute École d'Art et de Design, Geneva. Diameter: 29 cm (11½ in.). *Photo: Magdalena Gerber.*

Lesley Baker (USA), *Fly on the Wall*, 2010. Hand-built stoneware with screenprinted decals, laser decals, commercial decals and flocking, 46 x 61 x 10 cm (8 x 24 x 4 in.). *Photo: Lesley Baker.*

DECALS FROM MONO-LASER PRINTERS AND PHOTOCOPIERS

In the first edition of *Ceramics and Print*, there was a detailed description of what, at the time, was a remarkable transfer technology that involved photocopy toner. Photocopiers (and laser printers) work on the natural phenomenon of static electricity. Negatively-charged powder (toner) is dusted over a photosensitive surface which has been exposed to a projected image of the document or image to be photocopied. It clings to those areas of the image, text and pattern that are positively charged – the darkest. A sheet of paper is passed across the photosensitive surface (usually a drum), and a positive electrical charge below the paper surface attracts the toner from the drum to the paper. At this stage the image is in fine dust. It is fixed by passing through heated rollers which soften the toner and fuse it to the paper fibres.

Over 20 years ago, Australian artist Warren Palmer used a Canon photocopier to duplicate images, which were then removed from the machine before the paper passed through its heated rollers. The resulting paper print was exactly like the drawn monotype achieved by drawing through paper onto dry colour on glass or glazed tile. Even more remarkably, the transferred image fired a sepia colour, if the right machine was used. The fired colour is iron oxide, a by-product of the photocopy/laser-printing

Burnt mono-laser and photocopy prints. The ash residue with brown graphic indicates the machine that produced it has iron oxide in the toner. Grey or black print residue indicates that there is no ceramic colour. *Photo: Paul Scott.*

system. It forms an important part of the toner powder. In firing, the carbon, polymers and plastics burn away, leaving the iron.

There are two basic laser/photocopy systems. In one, iron oxide is a constituent of the toner, in the other (including all colour copiers/printers), it is absent from the colourant. It is easy to test whether a particular machine has the appropriate toner by simply burning a small piece of printed paper (see image, left). If iron oxide is present in the toner, the resultant delicate paper ash will display a brown/red print in its surface. If the ghost print is grey or black there is no iron in the toner.

In order to be fused and not powdery, these prints must be applied to surfaces where the body or glaze is going to vitrify. However, the amount of iron is very small so if glazed surfaces are melted for too long, the iron will often dissolve. Ideally use them on top of pre-fired glazed objects, re-firing them so that the glaze just begins to soften, allowing the iron to sink into the surface, creating an inglaze print. Alternatively, use on high-fire porcelain that has no glaze.

In older machines it can be relatively easy to remove the powder print by switching the copier off once the image has been scanned. Opening the machine in the way you would to remove jammed paper will reveal the powder print on the rubber belt, easily accessible. The printed image can then be transferred to a clay surface by simply laying the paper face down onto a prepared slab of clay and rolling gently, or scraping the back with a credit card or small squeegee. Upon removal, the image appears on the clay surface.

Over the years ingenious methods have been developed to remove fused toner from normal paper. One of the simplest is by sticking the print face down onto wet clay, then simply rubbing the paper away from the back of the print. Alternative methods have included melting the toner to the glazed surface with heat (an iron or electric paint stripper gun), or chemically, using solvents. Never mix the two methods.

Nowadays, fused toner can more easily be used in the production of transfers. Conventional decal paper with a gummed surface can be used in printers without a problem. It is good practice to run a sheet of ordinary paper through the machine after each print to ensure that there is no build up of gum on the printer rollers. The resulting decal can be covercoated in the conventional way or laminated. However, specialist pre-coated decal papers are now available for normal desktop laser printers and photocopiers. It is important to read the manufacturer or supplier information to ensure that you are using the correct paper, and it is always advisable to use the machines when they have just been turned on. Use of the wrong decal paper can result in expensive service/repair costs. The fusing unit in a printer that has been on all day or used intensively may be too hot and can cause pre-coated paper to melt onto the rollers. As with conventional paper, it is always good practice to print one decal followed by one sheet of plain paper, to avoid lacquer build-up on heated rollers.

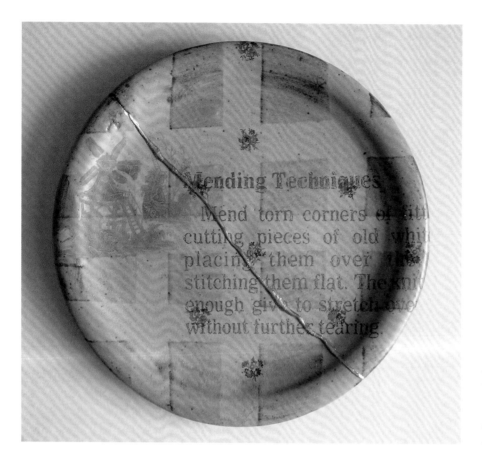

Amy Gogarty (Canada), *Mending*, 2004. Overglaze and inglaze decals on stoneware plate with photocopy decal prints, diameter: 25 cm (9¾ in.). *Photo: Amy Gogarty.*

Graciela Olio (Argentina), *Project South, Home Series*, 2011. Laser print (decal), gold and platinum lustres on Keraflex, 40 x 20 x 20 cm (15¾ x 7¾ in.). *Photo: Graciela Olio.*

Lenny Goldenberg (Denmark), *Beakers*, 2010. Laser print on white and blue porcelain. Note how the sepia print appears much darker on the blue form, 11 x 7 cm (4¼ x 2¾ in.). *Photo: Susie Mikkelsen.*

Jefford Horrigan (UK), *Hybrid IV*, 1995. Clay, fabric and laser print. Horrigan cloaks his raw clay sculptural forms with laser prints on paper. His sculptures remain unfired, 160 x 70 x 9 cm (63 x 27½ x 3½ in.). *Photo: courtesy of Jefford Horrigan.*

Rachel Kingston (USA), *Untitled 1967 (Clouds)*, 2006. Full-colour Novajet inkjet print on imperial porcelain. Handmade high-fired porcelain page, printed through flat-bed printer with raised heads, mounted into a cardboard framing device with adjusted ink density (print unfired), 27 x 18.5 cm (10½ x 7¼ in.). *Photo: Jai Kingston.*

Jenny Hodge (Australia), *Collapsed Casino*, 2009. 'Hodge Inkjet' prints on Keraflex porcelain, single-fired to 1280°C (2336°F), black and red underglaze, Japanese tissue paper. Keraflex impressively incorporates the print deep into its absorbent surface, 13 x 20 x 15 cm (5 x 7¾ x 6 in.). *Photo: courtesy of Jenny Hodge.*

INKJET PRINTS

Whilst industry has created special ceramic laser toner, inkjet technology has been adapted in a different way. With the exception of (solvent-based) lustres and water-soluble metal salts – chlorites, sulphates, nitrates – all ceramic colour is particulate. It is not technically feasible to integrate particulate pigments into water-based inkjet inks. Instead inkjet printers have now been developed which print a sticky medium onto ready-fired enamel and porcelain blanks. These are then dusted with overglaze or enamel colour. Using four colour separations in Photoshop, and equivalent ceramic colours, photographic images can be created by repeated printing and dusting.

Jenny Hodge has developed a studio version of the process, working on the principle of dry powders adhering to the wet surface of a printed inkjet transparency, which is then transferred to the clay surface.

3D printing

Three-dimensional printing seems a relatively new concept, but it could be argued that age-old techniques of slip-casting and press-moulding were forerunners of the new digital processes, producing repeated shapes, forms and patterns. Ane-Katrine von Bülow's graphically-cloaked slip-cast bowls (see p. 101) and Steve Brown's printed textile moulds have developed from these older technologies; they are exemplars of artists who are rigorously examining the synthesis of ceramic form and surface.

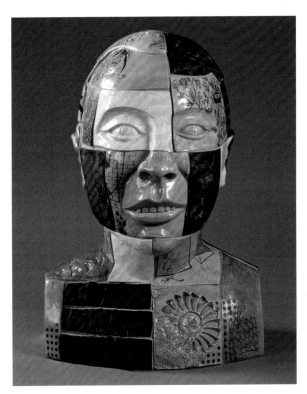

Michael Eden (UK), *Wedgwoodn't Tureen*, 2010. Designed on Rhino 3D and FreeForm software, printed in plaster by a ZCorp 510 3D-printing machineer. Infiltrated to give the gypsum material more strength, coated in a non-fired ceramic material, 41 x 26 cm (16 x 10¼ in.). *Photo: Nick Moss, courtesy of Adrian Sassoon.*

Steve Dixon (UK), *Liu Xiaobo Head*, 2012. Press-moulded in sections, glazed and unglazed earthenware clays, inglaze tissue transfer prints and onglaze water-based screenprinted decals. *Liu Xiaobo* was made in response to the awarding of the Nobel Peace Prize to Chinese dissident Liu Xiaobo in 2010, 65 x 47 x 46 cm (25½ x 18½ x 18 in.). *Photo: Tony Richards.*

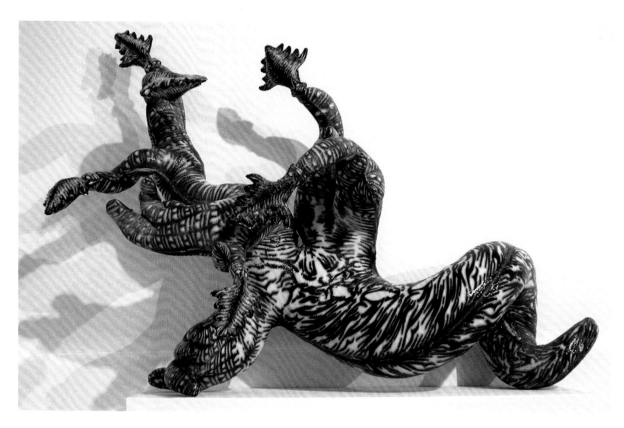

Steve Brown (UK), *Mandrake*, 2009. Flexible in-mould underglaze transfer print on porcelain, 115 x 90 x 20 cm (45¼ x 35½ x 8 in.). *Photo: Steve Brown.*

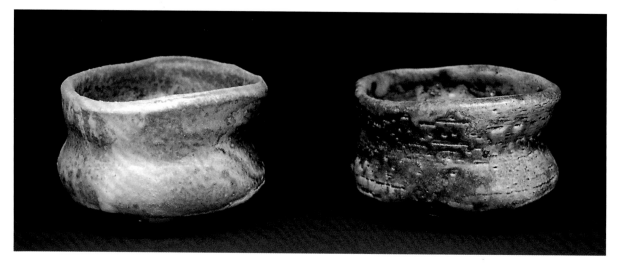

John Balistreri (USA), *Teabowl With Printed Clone*, 2010. Teabowl on the left was wheel thrown, teabowl on the right was three-dimensionally printed in stoneware from a digital file created by scanning the original thrown form. Both were fired to 1300°C (2375°F) in an anagama wood kiln, 10 x 10 cm (4 x 4 in.). *Photo: courtesy John Balistreri, Bowling Green State University, Ohio.*

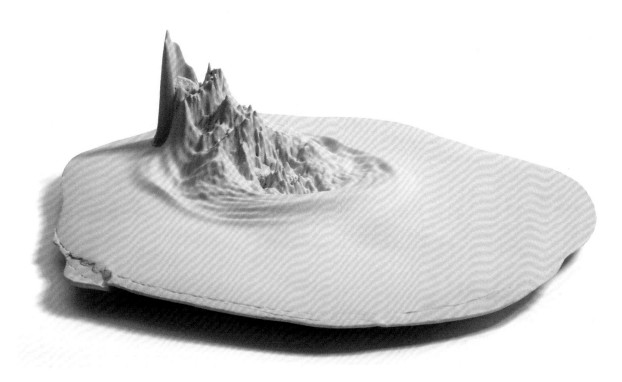

Flemming Tvede Hansen (Denmark), *Splash*, 2009. Slip-cast plastic print from a 3D printer using Real Flow software. Undertaken during PhD research funded by the International Ceramic Research Centre, Guldagergård, and the Royal Danish Academy of Fine Arts School of Design, Denmark, 45 x 40 cm (17¾ x 15¾ in.). *Photo: courtesy of Flemming Tvede Hansen.*

Powder printer in action at the National Academy of the Arts, Oslo. To the right, shapes in the powder have just been printed by the inkjet heads as they travel from right to left. The heads continue to the left then, on returning to the right, a blade drags a thin layer of powder over the wet marks in the powder, adding to the form being printed. *Photo: Paul Scott.*

Powder-printed form being unearthed in a printer at the University of the West of England research laboratory. *Photo: David Huson.*

Today's digital printing means more than the deposition of ceramic pigment onto decal papers. As in the case of laser printing, 3D printing in ceramics has developed as a result of the field adapting and using technology developed for other disciplines; in the case of 3D printing, from engineering and architecture. Three-dimensional printing relies on technology which effectively deposits thin layers of material on top of each other.

Two types of 3D printer are favoured by ceramic printers: powder deposition, using inkjet with powder, and fused deposition modelling (originally designed for melting plastic). The processes undertaken by both kinds of machine are surprisingly understandable when seen in action. Powder deposition involves inkjet heads depositing liquid onto a base, which is then coated with a thin layer of plaster or porcelain dust. The process is repeated, eventually building up the object. The fused deposition method extrudes clay in layers to build up the form.

An array of different software programs exist for creating 3D files suitable for printing. As with other technically-complex processes outlined in this book, it is advisable to undertake some personal research and perhaps a specialist course to develop understanding and competence.

Research into 3D-print technology has involved casting from plastic printed objects, coating printed plaster forms, substituting porcelain powder for the normal print medium (gypsum) and replacing extruded plastics with clay.

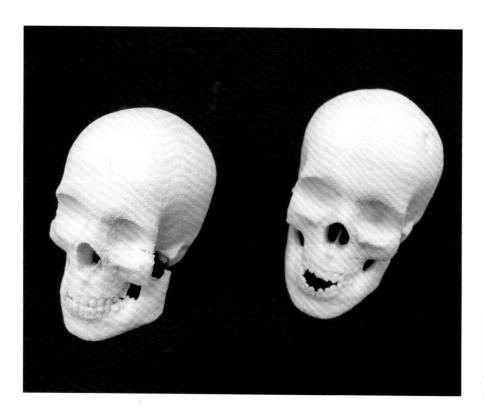

David Huson (UK) at the University of the West of England, *Skulls*, 2011. 3D powder-printed porcelain forms, height: 3 cm (1¼ in.). *Photo: David Huson.*

Jonathan Keep (UK), computer software and unfired printed music pots, 2012. Screen to the left shows processing of the open source programming language, based on Java, in which the code is written. Centre, an onscreen representation of the printed pot (foreground right) in Blender, the 3D modelling software program that Keep uses to clean up the digital form before it goes to the printer. 'This collection of pots has been textured with the input of musical sound recordings. The form is coded from the base up, with the pitch and rhythm of the music distorting the surface in a circular motion as the shape grows vertically. This result could not be achieved other than by 3D digital printing.' *Photo: Jonathan Keep.*

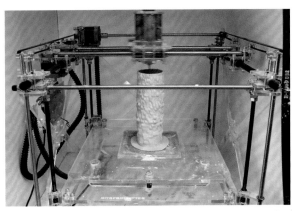

Jonathan Keep (UK), 3D printer building a form, 2012. The RapMan 3D printer is supplied as a hot plastic layer deposition extrusion printer flat-pack kit.[1] Keep has adapted it to use a homemade clay printing head, a clay-filled, pressurised syringe that oozes a constant fine coil of clay. The syringe is held in the mount, which plots out the horizontal axis from the digital file in one plane. The base platform sinks by one slice and the next layer or cross-section of the digitally-created form is printed. 'To see the form that was once just illustrations on a computer screen grow into a real, clay, physical object before your eyes is very exciting.' Final form: 50 x 50 x 50 cm (19½ x 19½ x 19½ in.). *Photo: Jonathan Keep.*

Jonathan Keep (UK), *Bark Pots*, 2011. Starting as a cylindrical mesh defined in computer code, these forms are distorted with an algorithm that produces the surface texture. The virtual form is then further cleaned up and scaled in a 3D modelling software package before being processed to produce a digital file for the 3D printer. Printed in porcelain clay, the forms are dried, fired and glazed in a conventional manner, 12 x 9 x 8 cm (4¾ x 3½ in.). *Photo: Jonathan Keep.*

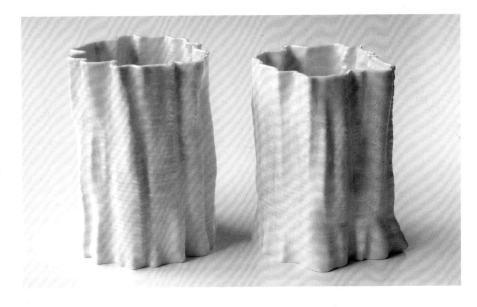

1 Supplied by Bits from Bytes of Somerset, UK.

Photographic emulsions

Direct photographic emulsions are liquid, light-sensitive emulsions applied to ceramic surfaces. After drying, they are exposed to light and developed. Some emulsions can be mixed with ceramic colour, or a light-sensitive film can be made which produces a latent image, revealed by pigment dusting. These kinds of photographic prints can be fired.

Photosensitive emulsions work by allowing light through a colloidal substance to activate light-sensitive chemicals. A colloid is usually an organic substance, soluble in water (gelatine, gum arabic, egg), which, when mixed with a light-sensitive chemical, takes on important characteristics. Some colloids are rendered insoluble when exposed to light and others lose their stickiness.

DIRECT PHOTOGRAPHIC EMULSIONS USING CERAMIC PIGMENTS

Gum bichromate is a 19th-century photographic process relying on the light sensitivity of dichromates, rather than the silver bromide used in conventional black and white photography. It works because of the selective hardening of gum arabic, pigment and ammonium or potassium dichromate when exposed to ultraviolet light. All processes, except exposure, are undertaken in subdued light.

Ceramic surfaces are coated with a gum dichromate solution, which is exposed to UV light through a negative transparency, ideally placed in contact with the emulsion surface. It is possible to have a full tonal range from black to clear as the light affects the coated dichromate gum mixture and its solubility to varying degrees. The print is developed in water, which washes away the gum and pigment from the unhardened, highlighted areas. In the case of prints to be fired, the colloid should contain ceramic pigments in the mixture, although even without these, dichromate does contain chrome and will therefore impart some finished colour.

An alternative method is the use of dichromate with gelatine and a sticky substance like honey, glucose or sugar. In this case the solution is applied to a ceramic surface and allowed to dry. It is then exposed with UV light through a positive transparency. Where the UV light strikes the film, it modifies the surface of the emulsion so that it is no longer sticky, but this is a gradual process, and the remains of the dichromated gelatine become less sticky in proportion to the amount of light falling on its surface.

Kit Anderson (UK), clockwise from top left: *Baby,* 1963; *Drink Drive,* 1974 (image courtesy of Picture the Past); *Time for Tea,* 2009; *Kitchen,* 1963; *Gallopers,* 2009; *Boy Racer,* 2009, 2012. Hand-tinted gum bichromate photographs with underglaze colours, 1100°C (2012°C), each, 15 x 15 cm (6 x 6 in.). *Photos: Kit Anderson.*

After exposure, the latent image is revealed by dusting the surface with a ceramic pigment. Most colour sticks to those areas least exposed to the light.

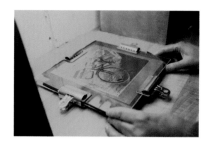

Ammonium and potassium dichromate are available from photographic suppliers. Both are potentially dangerous chemicals, and care should be taken when using them; always wear a dust mask and rubber gloves when handling them. Dichromate salts are toxic, and irritating to the skin and mucous membranes. Care must be taken to avoid even the slightest skin contact or breathing the powders in. Potassium dichromate is generally considered the less dangerous of the two.

Ammonium dichromate is faster to expose, whilst potassium develops with higher contrast. Exposure and contrast can be adjusted by the ratio of sensitiser to gum/pigment. Kit Anderson has undertaken artistic research into contemporary methodologies. She mixes a saturated solution of potassium dichromate with 100 ml (3½ oz.) of tap water, then keeps it in a labelled (mixture/date) chemist's brown bottle. She has found that a gum mixture works best on vitrified ceramics, and egg on bisque. For vitreous prints she adds equal amounts of dichromate solution to gum arabic, mixed to the consistency of golden syrup. A dichromate/egg mixture is made using 1 egg and 25 ml (¾ oz.) of saturated solution, using 3 to 1 of colourant (oxide or underglaze) for strong colour, 5 to 1 for medium, and 8 to 1 for light. This mixture is applied to the ceramic surface with a soft brush and allowed to dry.

Images can be created from negative or positive films, or by placing actual objects onto the light-sensitive surface. If using a negative, this is placed directly on top of the surface and held in place with clips or a glass sheet. Exposure is made using a UV light source. The developing image becomes clearly visible during exposure if the negative is lifted carefully at one corner. Printed colour washes out slightly on developing, so first experiments may only need judgement by eye for exposure times. The emulsion is developed by gently brushing the surface with cold water.

FROM TOP: Painting dichromate mixture onto glazed tile; exposing the tile; washing the tile. *Photos: Paul Dale.*

Ceramic pigments are particularly dense and may obstruct the passage of light through the emulsion. Gum printing is traditionally a process of multi-layering, in which thin layers are applied, then exposed. Repeating the process will progressively build up a thicker emulsion base. The process is one where no hard and fast rules apply, where experimentation can lead to subtle and delicate photographic qualities. The variants are the density of negatives or positives, type of light source (prints can be exposed using daylight instead of a UV lamp, but exposure times may be longer), length of exposure, strength of dichromate solution, colour (different pigments may require different exposure times), glaze and firing temperatures.

A commercially-available alternative to gum bichromate prints is Rockland's Pyrofoto toner.

Kit Anderson (UK), *Bike*, 2012. Gum bichromate print on earthenware tile, 15 x 15 cm (6 x 6 in.). *Photo: Kit Anderson.*

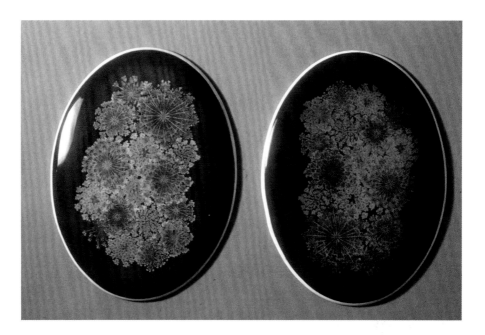

Mary Jo Bole (USA), *Dead Flowers as Incendiary*, 2004. Gum bichromate process with painting on enamel, 18 x 13 cm (7 x 5 in.). 'The images were put on the enamelled copper or steel pre-coated plaque, by a colloidal process, but the positive image could be generated on a computer. I love these examples of antiquated processes meshing/informing the new and vice versa. The colour was also enamel, you mixed the powder with rubbing alcohol rather than water. With its lower specific gravity, the alcohol/enamel mixture dries as powder where you can brush off the excess providing greater control.' *Photo: Chas Ray Krider.*

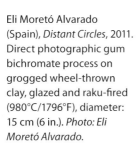

Eli Moretó Alvarado (Spain), *Distant Circles*, 2011. Direct photographic gum bichromate process on grogged wheel-thrown clay, glazed and raku-fired (980°C/1796°F), diameter: 15 cm (6 in.). *Photo: Eli Moretó Alvarado.*

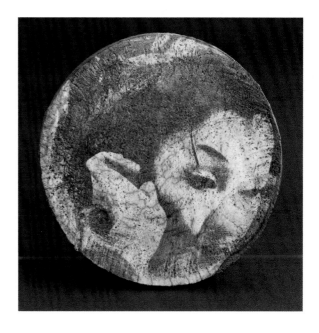

NON-FIRING PHOTOGRAPHIC EMULSIONS

Cyanotype

Cyanotype is a photographic printing process that gives a blue print. Developed in 1842 by Sir John Herschel, it was originally used as a way of reproducing notes and drawings (hence 'blueprints'). In 1843, botanist Anna Atkins used the process in a book on ferns, the first publication ever to use photographic illustrations. Cyanotypes are made from a mixture of ferric ammonium citrate and potassium ferricyanide. A typical recipe recommends mixing 100 ml (3½ oz.) water and 25 g (¾ oz.) ferric ammonium citrate in one bottle and 100 ml (3½ oz.) water with 10 g potassium ferricyanide in another. The two solutions are mixed in equal parts, then the ceramic surface coated using a soft brush. After exposure, the resulting image is an insoluble blue dye (ferric ferrocyanide) known as cyan blue. Unfired, the cyanotype references the classic ceramic blue and white semiotic of cobalt and porcelain, Delft and Staffordshire blue.

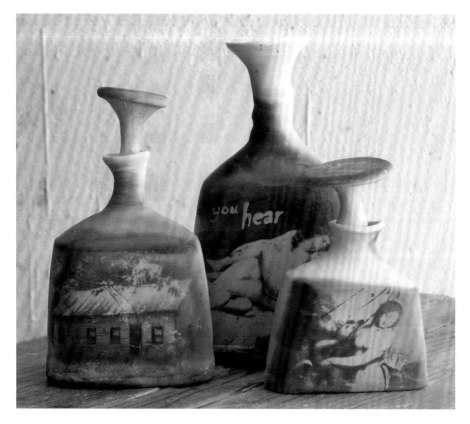

Rebecca Barfoot (USA), *Listen*, 2009. Cyanotype on Royal Copenhagen porcelain. Contact prints on vitrified bisque, created by exposing cyanotype sensitiser to sunlight through photographic negatives. The process also works on glazed ware. Height: 15 cm (6 in.). *Photo: Rebecca Barfoot.*

Liquid Light

Liquid Light and similar non-firing emulsions like Silverprint are designed to be used on a variety of surfaces. After coating ceramics under amber or red safelight, the dried emulsion is exposed with an enlarger or slide projector. As with paint, too thin a layer of emulsion will show streaks and brush strokes, so it may be necessary to apply multiple layers, allowing the emulsion surface to almost dry before re-application. After developing in conventional photographic developer, the emulsion is washed in running water to make the image archivally permanent. These types of emulsions do not contain hazardous chemicals.

As with other photographic emulsions, there are a number of factors that affect the quality of printed image. These include the nature of the surface, pre-coating, the method of application, thickness, the age of emulsion (Liquid Light has a shelf life and changes as it ages), exposure time and light source.

ShiKai Tseng (UK/Taiwan), *PhotoGraphy*, 2011. Liquid Light on fired ceramic forms. 'The meaning of photography is writing light, or using light to achieve the graphic. Light projected onto film makes the chemical layers react, then shows the colours or reverse colour of the illuminated objects on the film or photo paper. The artworks reflect a process in which environment, time and light react to each other and generate images on three-dimensional objects. This series is about coating objects with a light-sensitive layer. They are put in a black box with strategically-placed pinholes. These were exposed for 5 to 50 minutes depending on the brightness of the environment. It is a new way to capture a moment in time, no matter whether the image on the object is focused or losing focus, the object will carry the trace of its first moments of experience, its first exposure … We usually associate photography with a kind of illusionism that reduces the three-dimensional into the two-dimensional, but in this case, the three-dimensional will rather be translated into another three-dimensional reality.' *Photo: courtesy of ShiKai Tseng.*

Conclusion

The past 20 years has seen a great expansion in the technical possibilities of printing on ceramics. Some of this has been driven by new equipment or industrial process, but the majority of changes have come about because of artists' ingenuity and their material investigations. Research has been driven by artistic intent, often in individuals' studios but also, importantly, in the context of academic investigation. It has produced extraordinary developments in techniques and artwork, barely outlined or conceived of in the previous editions of *Ceramics and Print*.

Although ceramics and print have a long interwoven history, it has largely been neglected by both printmaking and ceramic departments in universities and art colleges. In light of this, current trends to dissolve traditional fields of study might seem to be an aid to greater synthesis. The danger in this approach is that material- and skill-based disciplines, which by their very nature require equipment, time and application, will fail to survive what are often economically-driven re-organisations. It is important to retain the 'material disciplines' in some form; the challenge is to preserve and at the same time enlarge fields, encouraging genuine openness and promiscuity of practice. Contemporary artists naturally move in and out of areas of study, seeing the opportunities of interdisciplinary working – but artistic expression without basic language can be limited and ultimately superficial. To develop coherence, artists require manual and digital skills, which need to be grounded in order to enable material understanding.

John Kindness has referred to the artist's studio as a cross between a 'lab and a playroom', and Marek Cecula has talked about the importance of material investigation to artistic practice, referring to design by trying, dropping, breaking, experimenting, 'not only from the head'.[1] In a world where instant, perfect objects are available at the click of a button and seductive new technologies bedazzle with slick interfaces, using raw materials can be a bit of a shock. With some patience, though, the experience of using physical tools, objects and processes can be immersive, alchemistic and deeply satisfying.

It would, of course, be wrong to infer that physical exploration is actually removed from the contemporary ubiquity of the computer. As this book demonstrates, material manifestations are often linked with digital harvesting, manipulating and processing. The interfaces of digital and physical technologies are key factors in the ongoing fascination with graphic ceramics. The computer provides an amazing array of tools

Leopold Foulem (Canada), *Green Flower Vase with a Bouquet of Wild Yellow Roses*, 2002–3. Foulem deals with stereotypes, with the history of ceramics, form, taste – and our perceptions of them. He consistently up-cycles materials. Referencing precious historical porcelain objects, this non-functional earthenware form is decorated with 'open stock' industrial decals. His objects are made of cheap counterfeit material. Perversely, of course, they are very precious and expensive because Foulem made them, 33 x 20.5 cm (13 x 8 in.). *Photo: Pierre Galivin.*

1 Marek Cecula, presentation at *Ting Tang Trash* conference 30th November 2011.

that enable artists to manipulate, conceptualise and contextualise. Digital mediation is an increasingly important element of contemporary practice.

Study in a field or discipline gives a visual language with which to articulate ideas. It should also give historical and contextual background so that artwork is not created in a vacuum. Printing on ceramics is actually very easy, but doing it well is less so. The best work is made knowingly.

Print, graphics and ceramics have all been at the cutting edge of new technologies and variously been the 'new media' of their times. They are woven into our perceptions and understanding of the world. This is why ceramics and print still have the ability to connect, involve and engage.

Happy printing.

Charlotte Hodes (UK), *Dish I*, 2003. Fragments of copper-engraved sheet transfer pattern onto Spode earthenware, diameter: 42 cm (16½ in.). *Photo: Peter Abrahams*.

Health and safety

You should be aware of the potential environmental and health and safety implications of any creative processes you undertake. Wherever possible, this book has encouraged the use of the least toxic materials available for any particular process. However, it is possible for individuals using print and ceramics to come in contact with a number of toxic substances – indeed, a combination of hazards common to the printmaker and the ceramist. The main routes of exposure to harmful chemicals are:

- **Inhalation.** The main route of entry for airborne chemicals and dusts. These can directly affect respiratory organs, but can also be absorbed into the bloodstream, bone, heart, brain and other organs. *Avoid inhalation.* Use non-hazardous chemicals. Ensure your work area has good ventilation, especially when using solvent-based products, oils, media, covercoat and cleaning solvents. Keep dry ceramic powder processes to a minimum, ensuring they are done with good local exhaust, and wearing a suitable respirator or facemask. Ensure an efficient cleaning system is employed in the studio to minimise dust production and circulation.
- **Ingestion.** Swallowing chemicals is not normal practice, but ingestion by accident is quite possible if care is not taken. Accidental ingestion by eating food, drinking and smoking in the studio or with dirty hands is the most likely. In addition, if chemicals have been inhaled, the lungs' natural cleaning system means these may be expelled by the lungs, and then can be swallowed. *Avoid ingestion.* Do not put contaminated hands or gloves near mouth or eyes. Do not eat, drink or smoke in the workshop. Clean hands thoroughly after working.
- **Skin contact.** Chemicals can be absorbed through the skin, entering the bloodstream. In particular, some chemicals cause skin allergies and irritation. Metal oxides can be absorbed through the skin with the danger of long-term cumulative effects. UV light is known to cause skin cancer, while other substances can cause ulcerations or burns. *Avoid skin contact.* Use the least toxic chemicals. Wear protective clothing, gloves and barrier cream. Dress any cuts or wounds properly and ensure they remain uncontaminated. Clean hands thoroughly after working, particularly under fingernails. Maintain high standards of hygiene in the workshop.
- **Injection.** Unlikely to be a major hazard in a ceramics or print studio, but ensure that sharp objects are cleared up and not hidden under sheets of paper, cloth or polythene.

The Control of Substances Hazardous to Health Regulations 1988 (COSHH) in the UK stipulate that every employer (including the self-employed) who uses, or whose

employees use, hazardous substances must assess their dangers, the precautions that are being taken and areas where control needs to be improved. 'Hazardous substances' include correction fluid, aerosols and glues, so practically every workplace is obliged to do at least a brief assessment. The results of your assessment must be recorded and may be examined by a Factory Inspector. See www.coshh-essentials.org.uk/assets/live/indg136.pdf.

In order to make your environmental and health and safety assessments, you need to be aware of the potential dangers of any process you undertake, and the properties of any materials you use. In the UK, when ordering materials, you are legally entitled to request Health and Safety Data information sheets (or MSDS reports in the US). These will detail any hazardous substance contained in the materials you have purchased, and recommend methods of storage, use and disposal.

LEVELS OF TOXICITY

A poison is a 'substance which when introduced into or absorbed into an organism destroys life or injures health' (Concise Oxford Dictionary). In reality, many substances regularly ingested in small quantities (alcohol, salt, caffeine, etc.) would be toxic if ingested in massive quantities. The human body has a variety of defense mechanisms against toxic materials, but if these are overloaded or fail for some reason, then poisoning is the result. Different people have different tolerances to poisons. An exposure level that may not have any perceivable effect on one person may be debilitating for another.

Nowadays there are defined Occupational Exposure Standards (OES) or Limits (OEL) over which a substance ceases to be regarded as 'safe'. OESs for gases, vapours and dusts are measured in parts per million parts of air (PPM), or milligrams per cubic metre of air (mg/m^3). Two criteria are used in expressing exposure limits: quantity and time. Time is quantified by Long Term Exposure Limits (LTEL) (generally eight hours working at a time, in a 40 hour week), and Short Term Exposure Limits (STEL) (which have a reference level of ten minutes).

If there is clear evidence of harm resulting from higher levels of exposure, the OES is given a Maximum Exposure Limit (MEL). This is also expressed with a LTEL and a STEL. (If you find you are working with materials with MEL then stop using them and find alternative products.)

When obtaining Health and Safety Data Sheets from manufacturers, the seemingly bewildering figures and chemical definitions are related to these limits. They are produced for industrial use, and are assumed to be of the exposure safe for 'healthy men', not children, women (especially when pregnant), the elderly, or people with illnesses, and it is difficult for the individual to monitor these figures. A more common way of realising that you are using hazardous substances is by product labelling. Extremely hazardous products are labelled 'Very Toxic', less hazardous 'Toxic', and below that come 'Harmful', 'Corrosive' and 'Irritant'.

CHILDREN

Children should not be exposed to toxic substances. They have a more rapid metabolism than adults, and so they are more likely to absorb poisons. They have smaller lungs and a smaller body weight, so safe levels for adults cannot be said to be safe for children. Any children working in the area of print and ceramics should be using non-toxic substances and processes (and this is quite possible). Your own children should not have access to your workshop if you are using toxic substances.

PREGNANT WOMEN

Risks to the unborn child are high, so pregnant or nursing mothers should avoid any exposure to toxic substances, solvents in particular.

HAZARDOUS SUBSTANCES IN CERAMICS AND PRINT

- *Ammonium or potassium dichromate.* Used in light-sensitive emulsions. Skin contact can cause allergies, irritation and ulceration. Chronic exposure can cause respiratory problems. Suspected carcinogen. Wear protective clothing, gloves and goggles. Explosive in dry state, contact with combustible materials may cause fire.
- *Clay.* Contains 'free' silica, hazardous in dust form. Long-term exposure to clay dusts can cause a lung-scarring disease called 'silicosis'. Ensure good workshop practice, eliminating dry clay processes if possible. Wet clean all working surfaces after use.
- *Covercoat.* Contains trimethyl benzene. Low order of toxicity, but irritant. High vapour concentrations can irritate nose and throat. Prolonged skin contact can cause dermatitis. Ensure good exhaust ventilation when using. Toxic emissions on firing.
- *Gum arabic.* Mildly toxic, can irritate the skin and respiratory system and cause sensitisation. Ensure good ventilation if danger of dusts or mist forming. Safest in liquid form, but shorter shelf life.
- *Lustres.* Contain a variety of chlorinated and aromatic hydrocarbons. Always ensure good ventilation when working, and especially on firing when carbon monoxide and hydrochloric acid may be a byproduct. Avoid skin contact.
- *Metal colouring oxides.* Vary in toxicity, some relatively safe (iron), others (cadmium, selenium, chromium, cobalt, vanadium) more toxic. Danger of long-term cumulative effects. Can be absorbed through the skin.
- *Oil-based printing media.* Variety of aromatic solvents. Check health and safety data sheets for specifics. Ensure good ventilation. Avoid skin contact.
- *Overglaze colours.* Contain small quantities of lead (in fritted form) and colouring metal oxides.
- *Plaster of Paris (calcium sulphate).* Dust is irritating to the eyes and slightly irritating to the respiratory system. Ensure good ventilation when mixing plaster, wear mask.

- *Turpentine, white spirit, other cleaning solvents.* A variety of solvents may be used in cleaning and thinning, of varying levels of toxicity. Can be absorbed through the skin; never clean hands with white spirit or turps, use a recognised hand cleaner. Ensure good ventilation during use. 'Odourless' white spirit has toxic aromatic hydrocarbons removed.
- *Underglaze colours.* Contain metal oxides in fritted form.

In addition to the above:

- *Ultraviolet light (UV)* emitted from carbon arc lamps, mercury vapour lamps (used for exposing light sensitive emulsions especially screen emulsions) is carcinogenic, and protective measures (goggles, clothing, etc.) should be observed when using these.
- *Computer screens* may cause headaches, eye strain, stress, etc. Ensure comfortable working position, and regular breaks from working in front of screen. Some people have cast doubt about pregnant women using VDUs because of possible increased risk of miscarriages. Check with your doctor or local Health and Safety Officer.
- *Cutting rubber or foam stamps* with a hot wire or soldering iron is likely to result in toxic fumes. Always ensure good exhaust ventilation.

The very nature of artistic activity means that experimentation is common practice. In all cases, the onus is on the artist to seek specialist advice. Initial information can be obtained from product manufacturers, and further information from health and safety officers or other relevant bodies.

WORKSHOP PRACTICE

Store all materials safely. Always ensure that products are clearly labelled. Never use old drinks or food bottles or containers unless removal of 'food' labels is possible, and only then when the result is that the container is unidentifiable as having been used for food or drink storage. Always ensure that hazardous chemicals are stored out of the reach of children.

Install an exhaust/ventilation system if possible. This can serve a number of purposes, from glaze spraying, using solvents and etching to removing kiln fumes. Do not attempt to do all these things together, and ensure complete cleaning up before changing operations! Ceramic powders, often supplied in plastic-lined paper bags, should be transferred to lidded non-breakable plastic containers. Ceramic powders resulting from ceramic activity should be minimised, and mixed with water as soon as possible (off-cuts from clay slabs, fettling).

Solvents or products containing solvents should not be kept in glass containers. When not in use, they should be stored in fireproof metal containers. Do not store near kilns, firing equipment or sources of heat. Store below head height to avoid damage to the eyes in the case of a loosely lidded container.

THE ENVIRONMENT

You are responsible if you pollute the environment as a result of your work and so it is important to minimise the environmental impact of your activities.

In practical terms, when using ceramic materials, you should install a sink trap. This is a tank underneath your sink into which your waste water drains, allowing ceramic materials in suspension to sink before the water is discharged into the drains and sewage system. In practice, this means that most glaze materials, metal oxides and underglaze colours are trapped in the tank, forming a sediment on the base. Every so often the tank should be emptied and the sludge or slurry of waste materials disposed of at a recognised landfill site. Some ceramists have suggested drying and firing the sludge so that the ceramic constituents are vitrified. Do not use a sink with a trap when using photographic developers, print media, acids or any kind of solvents.

If using solvents or oil-based products in your studio, never wash these down the sink. In the case of a sink trap, the fumes could build up in an enclosed space and create an explosive or fire hazard. Solvents are polluters of waterways; organic solvents destroy bacteria in sewage plants and septic tanks and prevent proper break-down of other wastes. They should be disposed of in an approved manner. Check with the manufacturer or your local authority about disposal. There are now recycling schemes for some solvents. Change to water-based inks and processes.

Use environmentally-friendly cleaning products. Conventional cleaning products can contain petrochemical derivative additives that can be polluting to waterways.

MAINTAINING A SENSE OF PROPORTION

Ensure that you do find out about all the materials you use. Follow health and safety advice on use, storage and disposal. Also, always maintain a sense of proportion. Materials are hazardous to the person or environment if not used properly, or if you fail to protect yourself or others from their effects. Few of the ceramic materials normally encountered in this book are hazardous to a degree that demands a 'toxic' labelling. Other chemicals relating to the print or photographic sections of processes may be, and you must make up your own mind about the desirability of using them, in your situation.

Bibliography and further reading

In a handbook of this size it is impossible to give full detailed information on the growing range of print and ceramics techniques, so the intent has been to show what is possible, giving some direction so that readers can start to investigate for themselves. This section suggests sources for further reading. In contrast to 1994, when the first edition of *Ceramics and Print* was published, there are now a number of specialist books on the field. These are always good starting points – the physical book is still a useful tool, sometimes much more suitable in the workshop environment than a Kindle, iPad or laptop. Digital resources are, however, increasingly rich. The web offers a vast amount of free information in the form of pages, videos and PDFs describing a wide range of techniques. The key to finding these is making good use of use of search engines with keywords, and exploring links from specialist web pages. Many of the artists featured in this book have their own websites; most have useful contextual information, while others focus on the technical. Manufacturers of materials and equipment, like Fujifilm Sericol (www.fujifilmsericol.co.uk), often have exceptional supporting information, usually to be found under *Support,* from starting up in screen-printing to emulsion troubleshooting.

Technical:

Barratt, M 2008, *Intaglio Printmaking,* A&C Black (Bloomsbury Publishing), London.

Bøegh, H 2008, *Handbook of Non-Toxic Intaglio,* Forlaget Bøegh, Denmark.

Gale, C 2006, *Etching and Photopolymer Intaglio Techniques,* A&C Black (Bloomsbury Publishing), London.

Grabowski, B 2009, *Printmaking: A Complete Guide to Materials and Processes,* Laurence King, London.

Petrie, K 2011, *Ceramic Transfer Printing,* A&C Black (Bloomsbury Publishing), London.

Petrie, K 2006, *Glass and Print,* A&C Black (Bloomsbury Publishing), London.

Reeder, D & Hinkel, B 2006, *Digital Negatives,* Focal Press, Oxford.

Wandless, P 2006, *Image Transfer on Clay,* Lark Books, Asheville, USA.

Contextual/Historical:

Carney, M 2008, *Lithophanes,* Schiffer Publishing, Atglen, USA.

Cecula, M (ed.) 2009, *Object Factory II,* Museum of Arts and Design, New York.

Clark, G 2006, *Ceramic Millennium: Critical Writing on Ceramic History, Theory and Art,* The Press of the Nova Scotia College of Art and Design, Halifax, Canada.

Cooper, E 2009, *Contemporary Ceramics,* Thames and Hudson, London.

Copeland, R 1990, *Spode's Willow Pattern and other designs after the Chinese*, Studio Vista, Cassell, London.

Coysh, A W & Henrywood, R K 1982, *The Dictionary of Blue and White Pottery 1780-1880, Vol. 1 & 2*, Antique Collectors Club, Woodbridge, UK.

Ehmann, S 2008, *Fragiles: Porcelain, Glass and Ceramics*, Gestalten, Berlin.

Failing, P 1995, *Howard Kottler Face to Face*, University of Washington Press, Seattle.

Halper, V 2004, *Look Alikes, The Decal Plates of Howard Kottler*, Tacoma Art Museum, Tacoma, USA.

Holdway, P & Drakard, D 2002, *Spode: Transfer Printed Ware 1784-1833*, Antique Collectors Club, Woodbridge, UK.

Scott, P 2000, *Painted Clay*, A&C Black (Bloomsbury Publishing), London.

Scott, P & Bennett, T (ed.) 1996, *Hot off the Press: Ceramics and Print*, Bellew, London.

Veiteberg, J (ed.) 2011, *Ting Tang Trash*, Bergen Academy of Art and Design (KHiB), Bergen, Norway.

Web resources: (see also specialist supplier web sites and customer support information)
Clay Prints Facebook group, www.facebook.com/groups/402841139758502
Non-toxic print resources, www.nontoxicprint.com
Non-toxic printmaking, www.grafiskeksperimentarium.dk
Kiln glass and fusing, www.warmglass.com
The author's website, with archived *Ceramics and Print* material and regularly updated web links relevant to the field, www.cumbrianblues.com
The International Ceramic Research Centre, Denmark, www.ceramic.dk
The Digital Ceramics Archive Research, Emily Carr University, www.ceramicsresearch.ca/web/
International Ceramics Studio Kecskemét, http://www.icshu.org
Manchester Institute for Research and Innovation in Art and Design, Manchester Metropolitan University, www.miriad.mmu.ac.uk
Oslo National Academy of the Arts, Norway, www.khio.no
The Shaw Centre for Ceramics at Medalta, Medicine Hat Canada, http://medalta.org
The artworks, writings and research of Paul Matthieu, www.paulmathieu.ca
Les Lawrence's virtual International Museum of Print and Clay. The sit is no longer updated so some links are dead, but it contains useful resources and information, www.printandclay.net
The Centre for Fine Print Research, University of the West of England, www.uwe.ac.uk/sca/research/cfpr/

Suppliers

The shrinkage of the ceramics industry in the west has had a profound effect on suppliers of materials and equipment. At the same time, *Ceramics and Print* has become an international publication, so extensive listings of UK- or US-based supplier addresses and telephone numbers are less and less relevant. This list of websites, compiled in June 2012, is designed to provide leads but is by no means comprehensive. Intelligent web searches will generally reveal localised suppliers of specialist materials and equipment. Where these are not available, the increasing globalisation of trade means that many materials can be quickly and efficiently dispatched all over the world.

Custom-made screenprint decals
www.dovescreen.co.uk
Also supply covercoat, small quantities of ceramic and glass colours in powder, ink or paste form, silk-screen meshing and stencilling supplies.

Digital decals
www.digitalceramics.com

General suppliers with print products
www.amaco.com
www.mnclay.com
www.potterycrafts.co.uk
www.potclays.co.uk
www.scarvapottery.com
www.sedgefieldpottery.co.uk – *including NovaDom and other print materials*

Keraflex
www.ceramicartcart.com
www.kerafol.com/en/home.html

Online marketplaces
www.alibaba.com
www.ebay.com
Usually feature suppliers of specialist materials, open stock decals, tissue prints, etc.

Open stock decals
www.baileydecal.co.uk
www.decorprint.com

Open stock tissue prints
www.chinaclayart.com/decal.html
www.chineseclayart.com/ChineseClayArt/store_decal.asp

Photographic
www.silverprint.co.uk
www.rockaloid.com
Liquid Light, cyanotype, gum bichromate, etc.

Polyester plates (lithography)
www.filmtechnik.co.uk – *suppliers of NovaDom polyester offset plates*
www.printmaking-materials.com

Photopolymer/solar plates (relief and intaglio)
www.grafiskeksperimentarium.dk/en/Materials.html
www.lawrence.co.uk/acatalog/Solar_Plates.html
www.solarplate.com

Pre-coated decal papers (photocopy/laser prints and water-based decals)
www.belldecal.com/laser_paper.html
www.fired-on.com – *specifically manufactured for mono-laser decals*
www.lazertran.com
www.papilio.com
www.tullis-russell.co.uk/coaters/products/trucal-and-specialisms.htm
www.johnpurcell.net – *U-WET water-based decal system*

Screen supplies
www.daler-rowney.com/en/content/acrylic-mediums – *System 3 print medium/glaze*
http://lascaux.ch/en/produkte/druckgrafik/index.php – *acrylic print medium/glaze*
www.folex.co.uk – *laser matt and drafting films for film positives*
www.fujifilmsericol.co.uk
www.speedballart.com
www.ulano.com
www.wickedprintingstuff.com

Index